#2400 YA 779.936 JOR

3/30/15

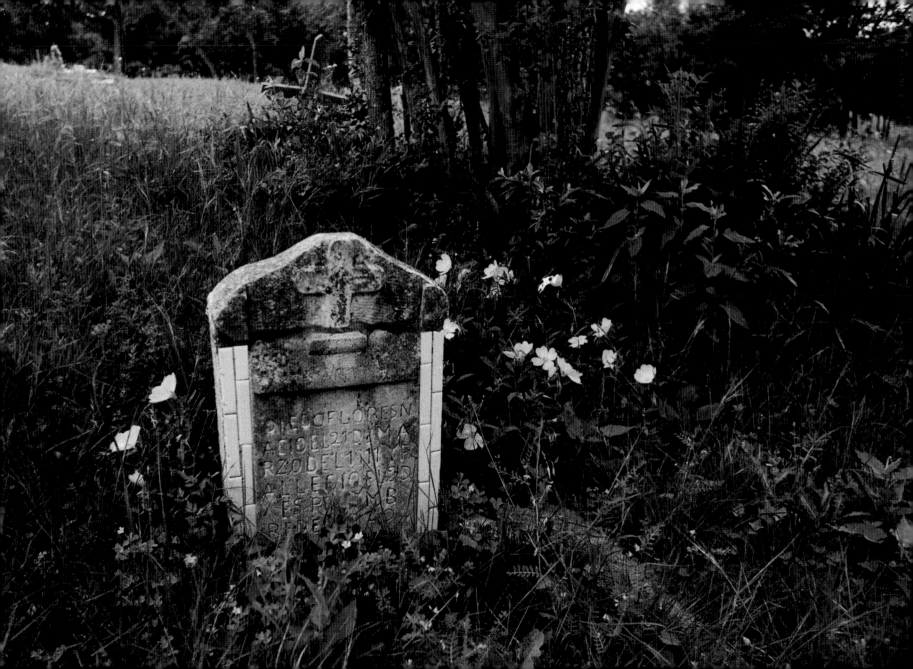

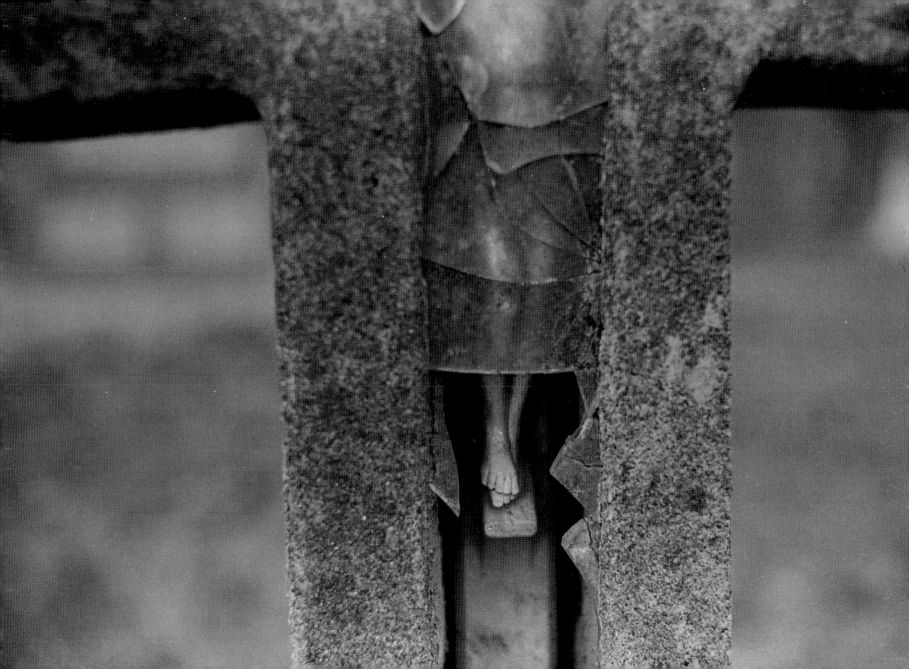

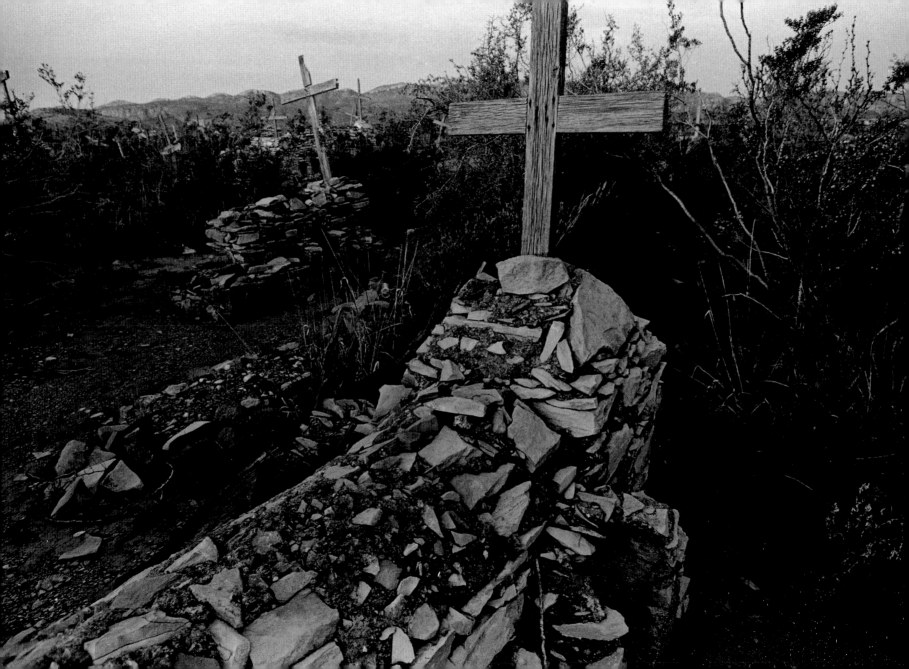

En Recuerdo de

The Dying Art of Mexican Cemeteries in the Southwest

BRUCE F. JORDAN

With essays by Martina Will de Chaparro and Tony Mares

With an interview by Bryce Milligan

UNIVERSITY OF NEBRASKA PRESS | LINCOLN AND LONDON

Publication of this volume was made possible in part through
the generosity of a donor who wishes to remain anonymous but
who would like to pass along to readers this thought from the
esteemed Ralph Waldo Emerson: "A friend may well be reckoned
the masterpiece of nature."

Library of Congress Cataloging-in-Publication Data
Jordan, Bruce F., 1953–, author, photographer.
En recuerdo de: the dying art of Mexican cemeteries in the South-
west / Bruce F. Jordan; with essays by Martina Will de Chaparro
and Tony Mares; with an interview by Bryce Milligan.
pages cm Includes bibliographical references.
ISBN 978-0-8032-4588-4 (cloth: alk. paper)
1. Photography, Artistic. 2. Cemeteries—Southwest, New—
Pictorial works. 3. Stone carving—Southwest, New—Pictorial
works. 4. Mexican Americans—Funeral customs and rites.
5. Jordan, Bruce F., 1953–. I. Will de Chaparro, Martina, 1967–
author. II. Mares, E. A., 1938–, author. III. Milligan, Bryce,
1953–, interviewer (expression). IV. Title.
TR655.J67 2014 779'.936375—dc23 2014009608

To Caleb Stephen Jordan, my son and companion on many journeys.

To Steve Maikowski, my lifelong friend, for his guidance and support of this project, both professional and personal. Here's to more adventures together.

To Andrea Maikowski, for her friendship, support of me and "my friend," and wonderful energy that lifts my spirit.

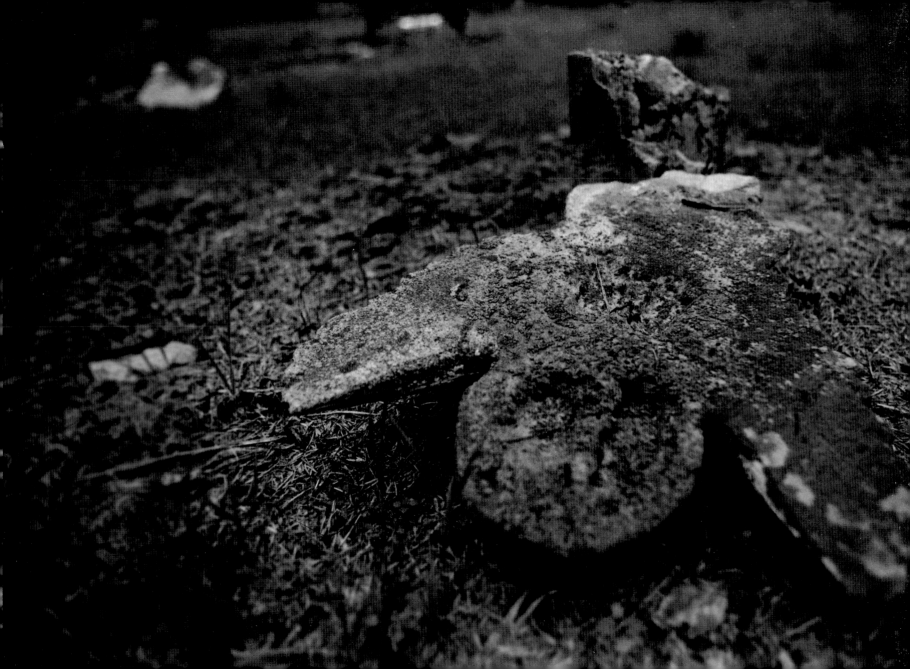

Contents

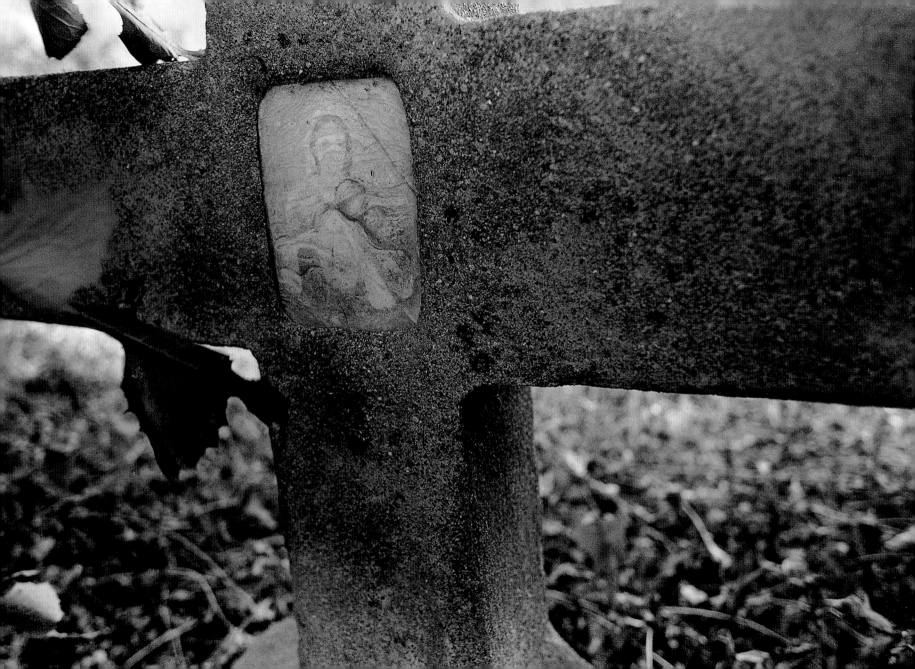

Acknowledgments

A special thanks to some very important people who made this project richer for their efforts and their patience:

Tony Mares—with your poet's eye you understood from the beginning what I wanted this project to say.

Martina Will de Chaparro—your essay gave this project its grounding and set up the adventure.

Matthew Bokovoy—champion editor who believed in this project at first glance many years ago.

Janey Lake—for guiding me to my first Mexican cemetery. It was a profound experience.

Betsy Dameron Joseph—for her poetic sensibility in understanding what I was trying to say and guidance in how to say it.

Ann Baker—for her careful eye in editing this project and patience in teaching me how to improve.

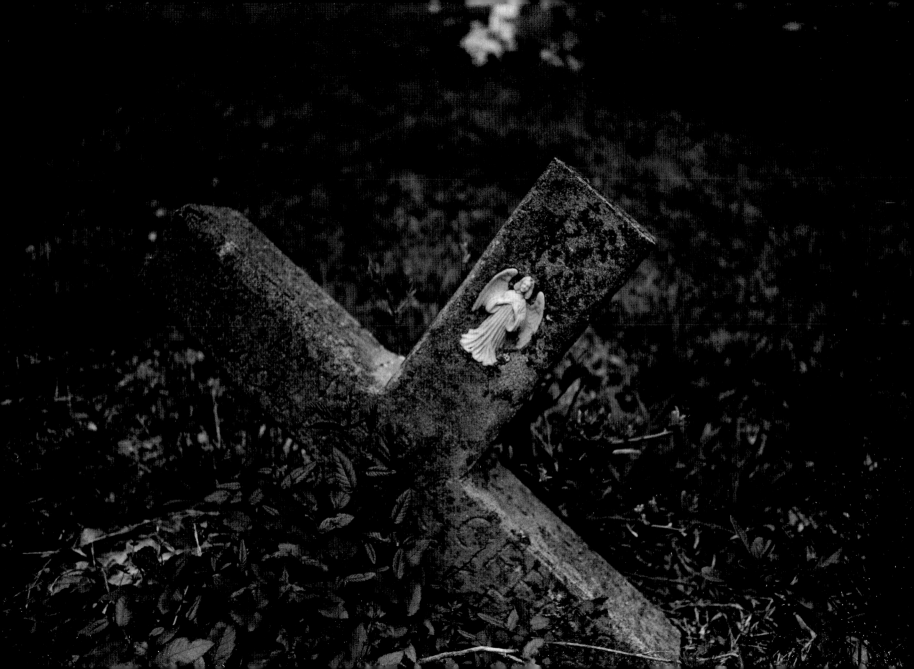

Bruce F. Jordan

The Dying of the Dying

This project is about culture, change, and the loss of cultural memory. It is a record of the past, of memory in images of the vanishing craftsmanship once seen in the Mexican cemetery.

My interest in this project, En Recuerdo de, or The Dying of the Dying, as Dr. Jose Limon calls it, came from several places. The most immediate influence came from my work on the book *Texas Trilogy: Life in a Small Texas Town*. My partner, Craig Hillis, and I spent time in the cemeteries in Bosque County, Texas, during our research phase. Through the dates, inscriptions, and occasional photographs on the monuments, we hoped to learn something of the folks who lived in the country long before the stories took place.

As a boy I played in the cemetery at church, my oldest influence. I became accustomed to the shapes and shadows as we played hide-and-seek throughout the headstones late at night. Darkness created a movie set and ignited my curiosity. I wondered about the people who were buried there. When were they born? How old were they when they died? Where did they come from, and how had they spent the days and years of their lives? What had they experienced in a time before I was born? I played there, sharing common ground with each of them, wondering.

While wandering through Texas cemeteries (Anglo, Mexican, Black, Polish, private, and others), I searched for glimpses of private and public histories. What became clear is that change takes place within all cultures. Old ways go by the wayside slowly, piece by piece, until one must make an effort and look closely to find what once was, perhaps perceiving a past. Old symbolism trades places with the new. Scraps of ancient ways are all that remain. Cultures become homogenized, blended. Distinctions become lost.

On a suggestion from a friend I visited a Mexican cemetery, my first, a few blocks away from her house in Austin, Texas. With my background in art coupled with an intense interest in different cultures, I was immediately drawn to the original artwork of these

older graves, some made as early as the nineteenth century. In other cemeteries I found a few graves with handmade efforts as recent as the year 2000. Many have no date at all, weather and time having worn away the carved or painted inscriptions, or the effort just too great to carve more than a simple cross. The age and individuality of each carving or construction, the different shapes and designs, the embedded artifacts—each personal—spoke to me of another world, another culture.

I imagined I could see craftsmen as they labored over every aspect of the creation. I wanted to meet them, spend time with them, listen to their stories and make their portraits. I wanted an artifact of their lives, a portrait, to take home. With that first experience the project began. My search took me through Texas, New Mexico, and southern Colorado. I could have traveled further, gathering more and more photographs and stories, but I found what I was looking for, so I came home.

Mexican culture is itself a mixture of cultures, originally indigenous and Spanish and now adding that of El Norte, expressing "the fluidity of culture," according to author Richard Rodriguez. When I think of the Mexican culture, I remember my experiences as a child in the shops and markets in Matamoros, Juarez, and Mexico City. I think of the carvings of the Aztecs and the great pyramids at Teotihuacan, as well as the small homes hand-built and pieced together by the poor. I see handmade crafts, textiles bright and patterned, and buildings painted with the colors of life, of the plants and birds found south of the border.

All of this speaks to me of a history of craftsmanship. Through these experiences the history of the Mexican people is, for me, first and foremost a visual history. Artistry and craftsmanship blend to mark their awareness of life and their creative gift.

Mexican cemeteries offer startling beauty that are examples of this artistic craftsmanship. Old gravemarkers, the oldest found along the drylands of the border, are often no more than simple rocks. Within the cemeteries, a cross of wood, or tree limbs nailed or wired together, or perhaps even scraps of milled lumber—if the community happened to be better off—are the things used to mark the life of an individual.

Slowly the craftsmen blended the skill of the laborer in wood and concrete with the "old ways" of decoration. Names are scratched in still-wet concrete, painstakingly written with wire or painted by hand. Shells and marbles and mementos, toys and figurines, all pay respect and tell stories of the deceased. From community to community, one—perhaps several—craftsmen left their individual marks. Each cemetery, therefore, looks different while still maintaining old customs that do not know the boundary of miles. The ingenuity is limitless. The love is still clear. As stories traveled with the movement of a people, the craftsmanship of the Mexican artist moved, too, northward. It is the craftsmen who have offered their personal styles and who have made each place special through the work of their hands and the love in their hearts.

I admire creativity and the handmade. In these old monuments can be found a people and a dying culture of craftsmanship. Few

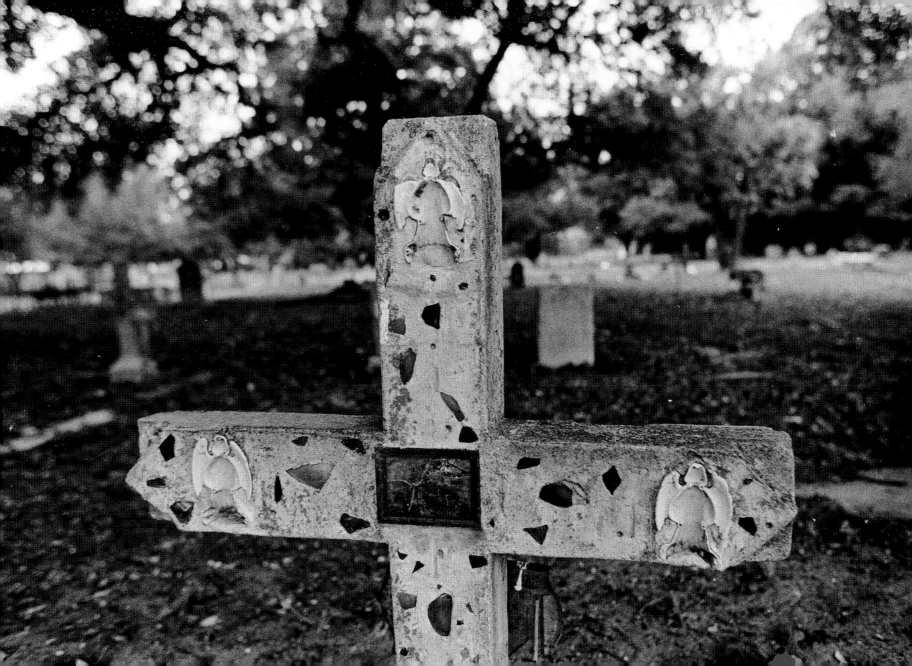

craftsmen are left to carry on this tradition. Monuments are slowly crumbling and being replaced with characterless granite. Many formal cemeteries no longer allow the often fragile constructions. Maintenance becomes troublesome, so new rules about what is allowed are created.

I think we are too casual about change. Change often happens so slowly that we do not perceive or truly understand what is taking place, the gains and the losses. Like the stories of a family that are lost when the last storyteller dies, the artistic culture of Mexican craftsmanship as seen in the cemeteries has faded, too. There are few new handcrafted tombstones. Characterless granite has replaced the wood, hand-formed concrete, carving, and marbles and shells placed just so. The rosary that was left hanging on a homemade cross or the statue of the Virgin is now carved into the granite by a laser. What was once vibrant and personal has become mass-produced and universal, and holds little meaning.

There is sadness in this. Individuals struggle to know themselves without stories and images. Little by little a culture becomes thin as the stories and images fade; details and reasons pass out of memory. Rodriguez believes that a new culture is created through this blending. That is true. The Mexican culture is becoming just this, a hybridization that has allowed the Mexican and Indian to survive. What about the way of life that has been lost in the meantime?

The old monuments that I first saw in the Cementerio Mexicano de Maria de la Luz came from a time, place, and people I cannot know. That is what hooked me the most. Older things, older people, are interesting to me, like stories I have never heard. "Character" is the word most commonly used to describe old people and old things; it is also what I see missing these days.

En Recuerdo de. In memory of.

EN RECUERDO DE

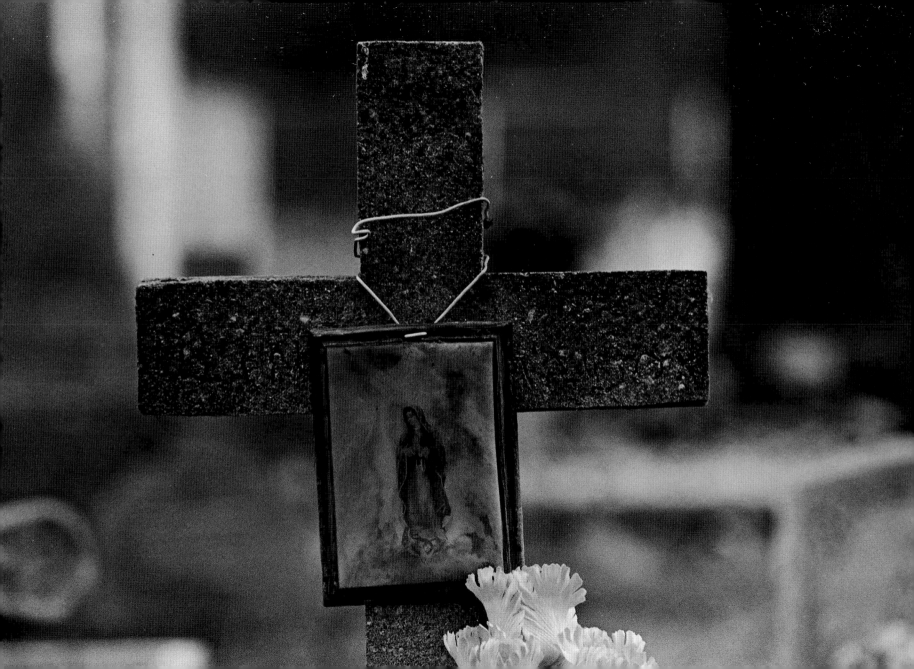

MARTINA WILL DE CHAPARRO

Relics of Time

Though Spanish settlers began making their homes in the modern Southwest a full decade before the first permanent English settlement took root at Jamestown, Virginia, we know surprisingly little about the Spanish population's deathways. Browsing a library bookshelf on the subject leaves one dizzy with titles documenting, depicting, and analyzing the cemeteries and gravemarkers of the Puritans, for example, who left a fascinating array of images and epigraphs engraved in stone for scholars to scrutinize and interpret. In contrast to the widespread and ongoing fascination with English colonial deathways, for a number of reasons—including the absence of surviving gravemarkers—historians, anthropologists, and others have paid relatively little attention to historic Southwestern burial practices and cemeteries. The lives and deaths of early Spanish settlers, who left no markers or only ephemeral ones, have all but disappeared from most Americans' awareness of our colonial past leaving no room for settlers' stories amid the soberly dressed Pilgrims and noble Hollywood Indians of the collective imagination.

This forgetting seems all the more insidious when one considers the profound role that the dead have played throughout history in fashioning the political imagination and especially in harnessing and maintaining authority.[1]

Though the Spanish continued to be the dominant European power in the Southwest through the first half of the nineteenth century, they did not create grisly death's heads or whimsical cherubs to populate their burial places. Religious beliefs, fear of desecration by enemy peoples, and other factors led most Spanish Americans to bury their dead within the floors of their parish churches until the early nineteenth century.[2] Burial within the nave of one's parish church was the norm for Spanish colonial subjects who could afford it; however, this practice seems to have been far more democratic in its operation in the Southwest than elsewhere in the Spanish-speaking world. In their wills, individuals petitioned to receive interment in both the most enviable and most humble of spots, depending on personal inclination. Regardless of whether they sought interment

in the chapel dedicated to the Virgin Mary or beneath the church's baptismal font, hope for a speedy release from purgatory united those who sought a church burial.

The type of "perpetual care" sought by Spanish Americans—those future "Mexicans" of the Southwest—thus differed radically from that which modern cemetery establishments envision. Catholics believe in the communion of the saints, which secures the faithful on earth, the souls in purgatory, and the saints in heaven in a "constant interchange of supernatural offices."[3] This ongoing relationship of the living with the dead led the faithful to anticipate that their bones would be watched over within the walls of the parish church, the very heart of the spiritual community. Here their souls might receive intercession from the Virgin Mary and the saints who presided over the different altars, as well as the benefit from parishioners' whispered supplications. Burial in proximity to the images and relics adorning the church facilitated saintly intercession on behalf of the dear departed, who could thus escape some of their sentences in purgatory. Though buried anonymously beneath the church floor, the dead therefore still enjoyed a place in the community's religious and social life. They heard mass regularly—including the weekly mass dedicated to the souls in purgatory—and silently witnessed the congregation's murmured prayers and pleas for forgiveness and salvation. Even as their spirits suffered purgatory's fires and their physical remains decomposed, the nameless dead thus remained an integral part of the community.

Those who had not warranted a burial plot within the church—the indigent, strangers, and others—nevertheless retained a toehold in the community's social life. Since the earliest cemeteries in the Southwest were actually the Catholic churchyards adjacent to the colonial churches, the faithful strode through the graveyard before entering within the sanctuary's cool walls. Like the sanctified space of the church, these consecrated grounds served the living as well as the dead and functioned as communal gathering places following the European custom. Here the living might sell their wares, hear edicts, or watch theatrical productions. Though by the late eighteenth century the Spanish Crown increasingly sought to curb or ban outright such practices, the cemetery in popular life was a far cry from the desolate, forgotten place we might today imagine it to have been.

Their very proximity to the living made the graveyards a special cause for concern as eighteenth-century reformers dutifully tackled public health dangers common to many urban areas: loose livestock, untethered dogs, putrid rubbish, fetid water, and decaying cadavers. Setting their sights on the burials that crowded many churches and churchyard grounds, Spanish and Mexican intellectuals and their adherents promoted new "ventilated" cemeteries to combat the dangerous miasmas that threatened the living with deadly diseases like cholera and smallpox.[4] These cemeteries were to be situated outside of population centers and, ideally, on elevated land. Proponents thought that these hillside locations would best allow for the circulation of air, thus mitigating and dissipating the dangerous odors emitted by the dead.

Several decades after the Spanish monarch first mandated these reforms in both Spain and the Americas, similar motives impelled reformers in Boston to establish the first rural or garden cemetery

in the United States, the Mount Auburn Cemetery (established in 1831). Copying the lead of Parisian authorities and the model of Père Lachaise Cemetery (est. 1804), Mount Auburn inaugurated a new style of cemetery in the United States replete with rolling hills, reflecting ponds, and meticulously landscaped grounds and plantings. Funerary monuments likewise assumed new forms, including headstones that depicted angels and urns, as well as innovative memorial art in the shape of cradles, angels, and life-size mourning figures. New Englanders thus vanquished the macabre *memento mori* of Puritan cemeteries in favor of sentimental and optimistic memorials that invited one to visit the cemetery and mourn at a loved one's grave.

While proponents wrote enthusiastically of Mount Auburn as the "Athens of New England" and tourists were willing to purchase guidebooks to better appreciate the Cambridge, Massachusetts, cemetery's many features, contemporaries in the American Southwest were reluctant to commence establishing cemeteries outside of urban areas. Though the king had mandated the construction of suburban cemeteries beginning in the late eighteenth century, noncompliance was commonplace. In the 1820s and 1830s, however, prompted by Spanish and then (after independence in 1821) Mexican authorities, communities began to construct cemeteries outside of towns. Though church burials allegedly continued to occur in some places well into the twentieth century, they became less and less acceptable as people became increasingly convinced of the health dangers posed by corpses decomposing beneath their feet. How and when individual communities raised funds, baked adobe bricks, and cleared land

for the new cemeteries remains a topic for future research. What we know from New Mexicans' experiences is that local *ayuntamientos* or city councils took the lead in building new cemeteries, but they also proceeded at a snail's pace, likely slowed by both a lack of resources and—initially, at least—popular aversion to the reforms. In Texas, a weakening of the regular orders who had been in charge of the missionization effort and a dearth of priests drove a movement to burial in unconsecrated family and community cemeteries in this same period.[5] Evidence from across the Southwest indicates that many historic cemeteries today lie buried beneath asphalt parking lots and roads, government buildings, and other urban architecture. Though innumerable cemeteries date to this time, only new burials (and new grave markers) kept them from all but disappearing from the landscape and from popular memory.[6]

Whereas in the Spanish colonial period the church itself had served as a marker for the dead, individual markers came into increased use with the establishment of the new cemeteries. Regardless of ethnicity, people from California to Texas constructed these early markers out of wood rather than stone, as would have been the case for markers identifying churchyard graves during the colonial period.[7] Terry Jordan suggests that people used wood for these markers due to its relative rarity "in semiarid districts, coupled with a desire to fashion the memorial out of something rare and precious."[8] Marble was even rarer than wood, however, as affirmed by the fact that the arrival, in 1879, of Tucson's first marble headstone—along with a wrought-iron fence—warranted mention in the city newspaper.[9] The most well-documented excavation of a nineteenth-century

cemetery in the Southwest sheds further light on the question of gravemarkers. Historic Alameda-Stone Cemetery, a predominantly but not exclusively Hispanic burial ground used from the early 1860s to the early 1880s, underwent a methodical excavation beginning in 2006 as the city of Tucson prepared to build a new courts complex on the previously built-over site. Though approximately two thousand people had been interred in the cemetery during its short lifespan, archaeologists did not uncover evidence of any headstones or other markers. Experts suspect a two-fold reason: "(1) the entire cemetery area had been graded and built over and was hidden for many years; and (2) many of the markers used may have been made of wood or other less-permanent substances."[10] We know from other cemeteries in the Southwest and West that wooden gravemarkers, sometimes including headboards and footboards, were the norm in the late nineteenth century.[11] As late as 1883, Tucson's Camp Lowell Cemetery—established by the U.S. Army in the 1860s and therefore arguably more "Anglo" than "Hispanic" in character—possessed only a single marble headstone.[12] The body of evidence, small though it is, therefore suggests that not ethnicity but geography and wealth were the most significant determinants in the construction composition of gravemarkers in the Southwest.

In some instances field stones served as gravemarkers but these were, in their own way, equally ephemeral and reliant on human memory. Once the writing on the wooden cross had faded or the elements had splintered or worn away, little reminder of the dead remained visible to passersby. Only if family members diligently replaced these markers did they achieve a semblance of permanence.

New Mexicans who migrated to southern California in the early 1840s, for example, buried their dead for generations in Colton, California, but left few if any markers that survived into the 1990s.[13] We can imagine how the earliest gravemarkers looked, for E. Boyd writes that, "in the second half of the nineteenth century when they [New Mexicans] already had the tools to do so, there was a flowering of decorative wooden markers, mostly of cruciform shape, which constituted a new form of sculpture in the whole region."[14] Earlier travelers' accounts tell of cemetery crosses and roadside crosses in the countryside, yet even in the Southwest's many surviving historic cemeteries, the oldest headstones frequently are late nineteenth-century ones, further evidence of these markers' transient character.

As both cemeteries and stone markers are newcomers to the Southwest, the photographs contained in this volume document relatively recent customs, historically speaking. The traditions represented are themselves now wavering due to a number of factors, some of which Tony Mares articulates in his essay. Though none of the elements pictured here—personal objects at the grave, iconography, concrete curbing, homemade craftsmanship—are entirely unique to Mexican American cemeteries, when brought together they create a distinctive sense of place. This uniqueness is in part a product of the apparent disorder and crowding that the conjunction of these elements conveys. As early as 1916, a guide to San Antonio, Texas, noted of the city's San Fernando Cemetery:

One of the most noticeable things in this city of the dead is the crowded appearance of the graves, many of them seeming to

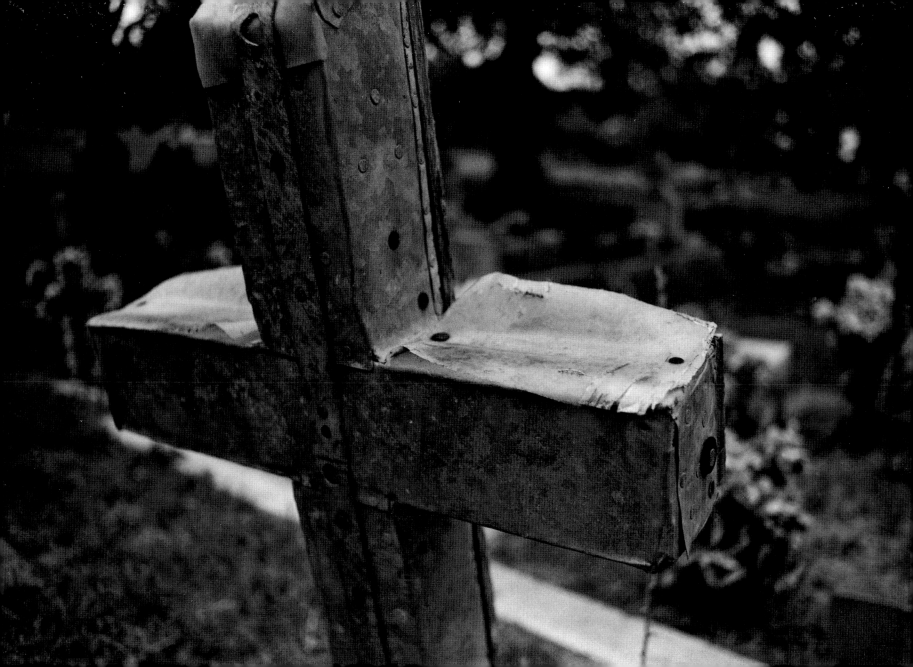

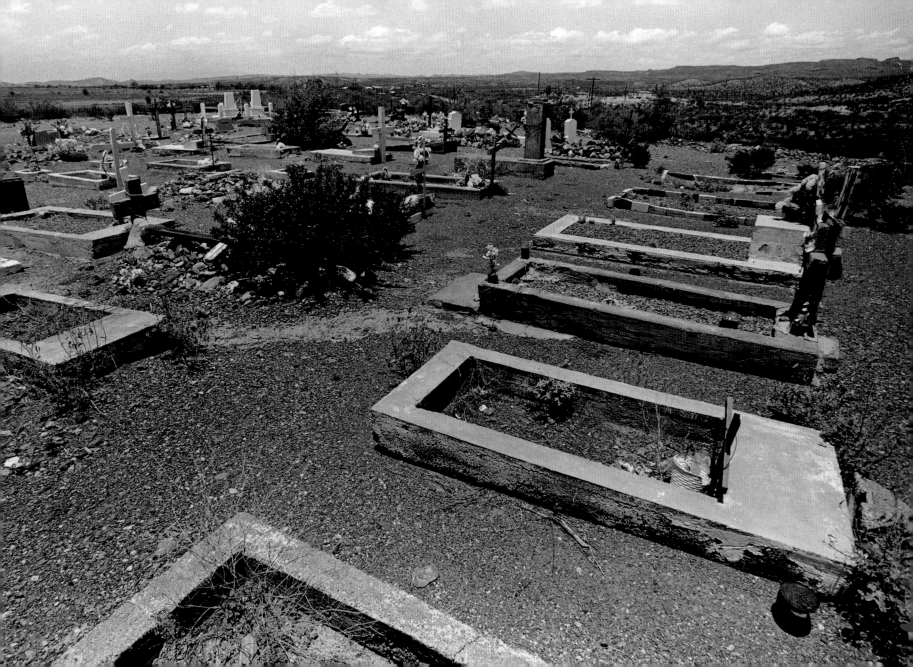

almost overlap, so necessary has it been to conserve space. These well-kept graves are mostly marked with white or black wooden crosses, the crude handiwork of a loved one left behind. On many of them are placed tin or wooden boxes with glass fronts draped like windows, in which some souvenir of the dear departed has been placed."[15]

In addition to the crosses and reliquaries holding tokens of remembrance of the dead, the author observes the presence of many personal objects: "A baby's cradle placed above a tiny mound, or a broken toy . . . a cross made by electric light globes set into the ground."[16] These commonplace items become strangely intimate in their placement on the grave. They suggest a desire to affirm life even in the midst of death, to grasp worldly attachments despite the belief in something better for the dead. Even after the passage of almost a century, the writer could be describing any of a number of the cemeteries pictured within the present volume.

While the landscapes in these gathered photographs vary from wooded to barren, and the graves themselves may be mounded or flat, the sentiments expressed appear to be constant: faith, love, and hope, emotions evident among many religious traditions and peoples as they confront death, are woven throughout the images. Many of the landscapes of the dead photographed herein are distinctly Catholic in their inclusion of the Virgin Mary, whose popular role as mediator dates at least to the eleventh and twelfth centuries.[17] People asked for her intercession at death and hoped that she would advocate on their behalf before the heavenly tribunal. Her maternal presence at the grave likely expresses a hope for her loving intervention in the afterlife, as the "Hail Mary" prayer also reflects: "Pray for us sinners, now and at the hour of our death." The frequent appearance of Christ on the cross or a cross alone also serves as a reflection on mortality and the hope for everlasting life.

More of this world than the next one, however, are the fences or *cerquitas* frequently seen in Mexican American cemeteries, which separate graves as though demarcating private property. This appears to be a fairly modern practice, arriving with other Eastern transplants to the Southwest after the war with Mexico (1846–48). In the 1840s and 1850s in the northeastern United States, families began enclosing cemetery plots within elaborate decorative cast-iron fences. Early Anglo settlers in Texas and New Mexico placed special orders to eastern manufacturers for headstones and iron fencing, as John Kingsbury did when his wife died en route to Santa Fe in 1857. Though Kingsbury had thought to bring a casket along on the journey with his ailing wife, Kate, he had to order the "neat white marble gravestone with a base stone suitable to set it in, and small footstone" along with "a light iron fence to enclose the grave."[18] New Mexicans' funeral expenses in the 1870s and 1880s often included expenditure for "iron railing," even as pragmatism dictated change in the 1860s and 1870s in the northeast. Finding the iron fences expensive to maintain, the new fashion became to use low concrete curbs to demarcate postmortem family property boundaries.[19] Eventually this trend made its way to the Southwest as well, but in Mexican American cemeteries these concrete curbs—like the iron fencing that still appears in some cemeteries—isolate individual burials rather than

outline the contours of a family plot.[20] Were it not for the curbing, in some cases no evidence of a grave would remain at a particular site. Overgrown vegetation threatens to return some graves and their cemeteries to the earth.

Established well before "perpetual care" entered the lexicon, Mexican American cemeteries might in time be considered permanent only by their inclusion in the photographic record. To be sure, the neglect and disruption of these historic sites is neither unique to Mexican American cemeteries nor new to the twenty-first century. Cemeteries of all types throughout the country have been built over. Whenever communities sought land through which to plot a new railroad track or road, these silent residents' terrain has often been the first to be sacrificed. Many cemeteries were segregated until at least the 1960s, and it should not come as a surprise that ethnic minority cemeteries have been surrendered to development. The most disenfranchised of the living could least effectively fight incursions. As a result, historic ethnic cemeteries probably have experienced a disproportionate share of displacement, overbuilding, and removal. Though an entire book could be written on this subject alone, a few examples should suffice. At least two hundred years of interments from the Old Spanish Cemetery in Nacogdoches, Texas—the county's oldest cemetery—were moved in 1912 so that the county could construct a courthouse atop the property.[21] Sometime in the 1940s, Santa Feans built a road and houses in the heart of a cemetery dating back to the 1830s or 1840s. Though the cemetery existed until at least 1936, the community forgot about the place's existence until 2003, when a construction crew working to establish new utility connections unearthed human remains while excavating the area.[22] Officials in Dallas likewise paved over an acre of a cemetery founded by freed slaves in 1869, so that the city could construct an interstate in the 1940s. The remaining untouched cemetery sprouted playground equipment and picnic tables, and was transformed by the city council into a park in 1965 even as the dead reposed beneath. When the city later sought to expand the highway, archaeologists exhumed the remains of 1,157 individuals.[23] These examples demonstrate the larger pattern of neglect and forgetting, development and remembering.

Though development may paradoxically force a community to remember the dead as graves expose their contents to a backhoe, as land pressures increase communities will continue to discover new reasons to plow through and build over cemeteries of all ethnic groups and religious denominations. As a society we must eventually reconcile the desire for perpetual care with the reality of limited natural resources and finite space. Deathways, themselves the product of ever-changing cultural impulses, will in turn shift and adapt to these considerations. New beliefs and technologies will transform mortuary practices in the future as they have in the past. In doing so, however, it behooves us to maintain our links to the past in the remarkable cemeteries that survive. Though it is a cliché and sentimental to observe that once these places are gone they are gone forever, it is nevertheless true. As powerful as the photographic record may be, it is a thin substitute for the experience of wandering through a historic cemetery on a late fall afternoon, discovering the treasures of individual lives represented in wood, stone, and concrete.

Ultimately these places are themselves historic documents that merit our perpetual care. In popular memory, U.S. history begins with Plymouth Rock or Jamestown. Would the presence of historic cemeteries in New Mexico and Texas have altered this perception? Would death's heads and cherubs be enough to sustain an awareness of the Spanish role in our nation's history? Though impossible to answer, the questions themselves suggest something of the power of historic cemeteries.

NOTES

1. See, for example, Matthew D. Esposito, *Funerals, Festivals, and Cultural Politics in Porfirian Mexico* (Albuquerque: University of New Mexico Press, 2010); Gary Laderman, *The Sacred Remains: American Attitudes Toward Death, 1799–1883* (New Haven: Yale University Press, 1996); Michael Sappol, *A Traffic of Dead Bodies: Anatomy and Embodied Social Identity in Nineteenth-Century America* (Princeton: Princeton University Press, 2002); Ruth Richardson, *Death, Dissection, and the Destitute* (Chicago: University of Chicago Press, 2000); David R. Roediger, "And Die in Dixie: Funerals, Death, and Heaven in the Slave Community, 1700–1865," *The Massachusetts Review* 22 (1981): 163–83; Michael Meranze, "Major André's Exhumation," in *Mortal Remains: Death in Early America,* ed. Nancy Isenberg and Andrew Burstein (Philadelphia: University of Pennsylvania Press, 2003): 123–35; Matthew Dennis, "Patriotic Remains: Bones of Contention in the Early Republic," in *Mortal Remains: Death in Early America,* ed. Nancy Isenberg and Andrew Burstein (Philadelphia: University of Pennsylvania Press, 2003): 136–48.

2. We know this to be the case for northern New Mexico, and, while practices elsewhere in the border region may have differed, because it is the most densely populated of the Spanish settlements in the Southwest, New Mexican practices are arguably especially significant. Anecdotal and archeological evidence suggest that the practice was common in Texas as well. William Corner, *San Antonio de Bexar: A History and Guide* (San Antonio: Bainbridge and Corner, 1890), 11; Meredith Schuetz-Miller, *The History and Archeology of Mission San Juan Capistrano, San Antonio, Texas* 1 (Austin: State Building Commission, Archeological Program, 1968), 213; Cynthia Tennis, *Archaeological Investigations at the Last Spanish Colonial Mission on the Texas Frontier: Nuestra Señora del Refugio* 1 (Austin: Texas Department of Transportation, Environmental Affairs Division, Archeological Studies Program, San Antonio TX: Center for Archaeological Research, The University of Texas at San Antonio, 2002), 151, 155–56; Martina Will de Chaparro, *Death and Dying in New Mexico* (Albuquerque: University of New Mexico Press, 2007), chap. 4.

3. "The Communion of Saints," *Catholic Encyclopedia*, http://www.newadvent.org/cathen/04171a.htm, accessed July 9, 2007.

4. See Pamela Voekel, *Alone before God: The Religious Origins of Modernity in Mexico* (Durham: Duke University Press, 2002).

5. Terry Jordan, *Texas Graveyards: A Cultural Legacy* (Austin: University of Texas Press, 2004), 67.

6. Scholars continue to debate and dissect nomenclature. For the purposes of this essay, I use the term "Spanish American" to refer to the people and time period of Spanish colonization in the Southwest, which ended with Mexican independence in 1821. For the sake of clarity, I employ the term "Mexican American" when discussing later people and later cemeteries in the United States that are of Mexican descent. "Mexican" I define narrowly, as a Mexican national—or, in the case of cemeteries, sites located within the boundaries of the nation of Mexico.

7. E. Boyd, "Crosses and Camposantos of New Mexico," in *Camposantos: A Photographic Essay,* ed. Dorothy Benrimo (Fort Worth: Amon Carter Museum of Western Art, 1966), 1–4; Robert H. Adams, "Markers Cut by Hand," *American West* (1967): 59–64; Russell J. Barber, "The Agua Mansa Cemetery: An Indicator of Ethnic Identification in A Mexican-American Community," in

Ethnicity and the American Cemetery, ed. Richard E. Meyer (Bowling Green OH: Bowling Green State University Popular Press, 1993), 162. See also Scott O'Mack, "Tucson's National Cemetery: Additional Archival Research for the Joint Courts Complex Project, Tucson, Arizona," Technical Report 06-56 (Statistical Research, Inc., 2006), 36, 42–44, re. gravemarkers.

8. Jordan, *Texas Graveyards*, 75.

9. O'Mack, "Tucson's National Cemetery," 43.

10. See Michael Heilen and Marlesa A. Gray, eds., *Deathways and Lifeways in the American Southwest: Tucson's Historic Alameda-Stone Cemetery and the Transformation of a Remote Outpost into an Urban City*, vol. 1: *Context and Synthesis from the Joint Courts Complex Archaeological Project* (Tucson, Arizona, 2010), 288, available at http://www.pima.gov/jointcourts/finalReport.html. The predominantly Hispanic Dove Cemetery in San Luis Obispo County, California, likewise shows little evidence of stone markers; of seventeen excavated burials, only two markers and the fragment of a third surfaced in this cemetery that dates to the 1860s. See Kristin Sewell, "Dove Cemetery: Reflections on Cultural Identity on the Edge of Western Expansion, The Excavation and Interpretation of Dove Cemetery," CA-SLO-1892H San Luis Obispo County, California (with P. Stanton). Technical Report 06-55 (Redlands: Statistical Research, 2006): 143–46. Anne A. Fox, "A Study of Five Historic Cemeteries at Choke Canyon Reservoir, Live Oak and McMullen Counties, Texas," offers little evidence of nineteenth-century gravemarkers; the stone markers found at these cemeteries all seem to date to after the turn of the century. This is a publication of the Center for Archaeological Research, University of Texas at San Antonio, Choke Canyon Series: vol. 9 (1984): 51–52. It is available at the UTSA Digital Libraries Collection-Center of Archaeological Research at http://digital.utsa.edu/cdm/landingpage/collection/p15125coll8.

11. See James Brock and Steven J. Schwartz, "A Little Slice of Heaven: Investigations at Rincon Cemetery, Prado Basin, California," *Historical Archaeology* 25, no. 3 (1991: 87, and Jordan, 1990: 44–47.

12. Scott O'Mack cites both photographic and newspaper evidence to substantiate this claim. O'Mack, "Tucson's National Cemetery," 36.

13. Barber, "The Agua Mansa Cemetery," 156.

14. Boyd, "Crosses and Camposantos of Mexico," 3.

15. Ione Williams Tanner Wright, *San Antonio de Béxar: Historical, Traditional, Legendary. An Epitome of Early Texas History* (Austin: Morganca. 1916), 134.

16. Wright, *San Antonio de Béxar*, 134.

17. Jaroslav Pelikan, *Mary through the Centuries: Her Place in the History of Culture* (New Haven: Yale University Press, 1996), 131.

18. John M. Kingsbury, *Trading in Santa Fe: John M. Kingsbury's Correspondence with James Josiah Webb, 1853–1861*, eds. Jane Lenz Elder and David J. Weber (Dallas: Southern Methodist University Press, 1996), 82-83.

19. Blanche Linden-Ward, "'The Fencing Mania': The Rise and Fall of Nineteenth-Century Funerary Enclosures," *Markers* 8 (1990): 35–58.

20. Economics probably had something to do with this cultural difference, as acquisition of a family plot would have required greater financial outlay than required for an individual burial.

21. Catherine Ann Pulley, "Cemeteries of Nacogdoches County, Texas, Since 1542" (master's thesis, Stephen F. Austin State University, 2003), 88.

22. H. Wolcott Toll et al., "La Garita Camposanto: Work at a Forgotten Cemetery under Kearny Road, Santa Fe, New Mexico, 2003 and 2005," Archaeology Note 358 (Santa Fe: Office of Archaeological Studies, New Mexico Department of Cultural Affairs, 2006): 1; Will de Chaparro, *Death and Dying*, 168.

23. James M. Davidson, "Mediating Race and Class through the Death Experience: Power Relations and Resistance Strategies of an African-American Community, Dallas, Texas (1869–1907)" (Ph.D. diss., The University of Texas at Austin, 2004), 3.

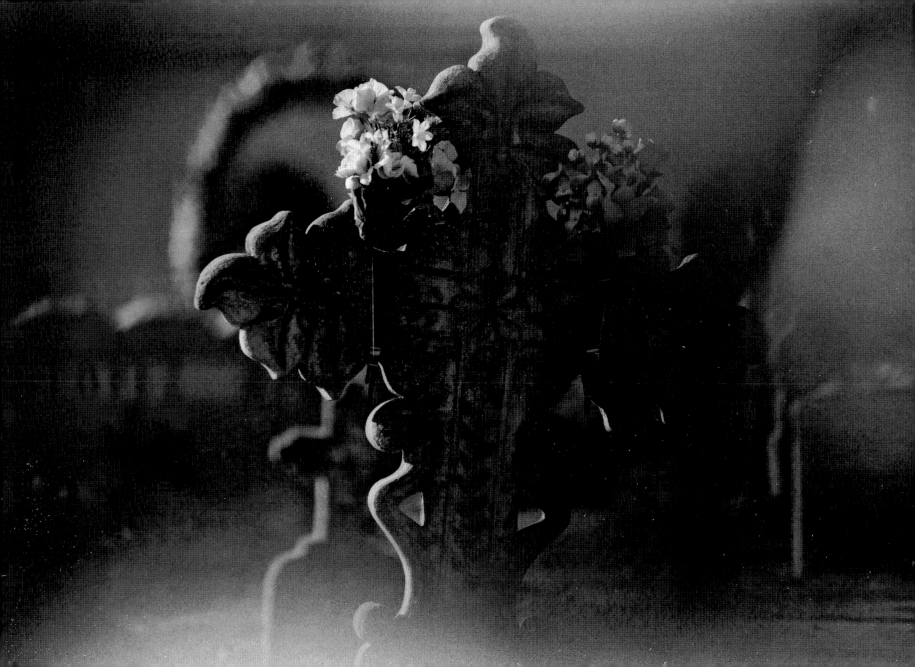

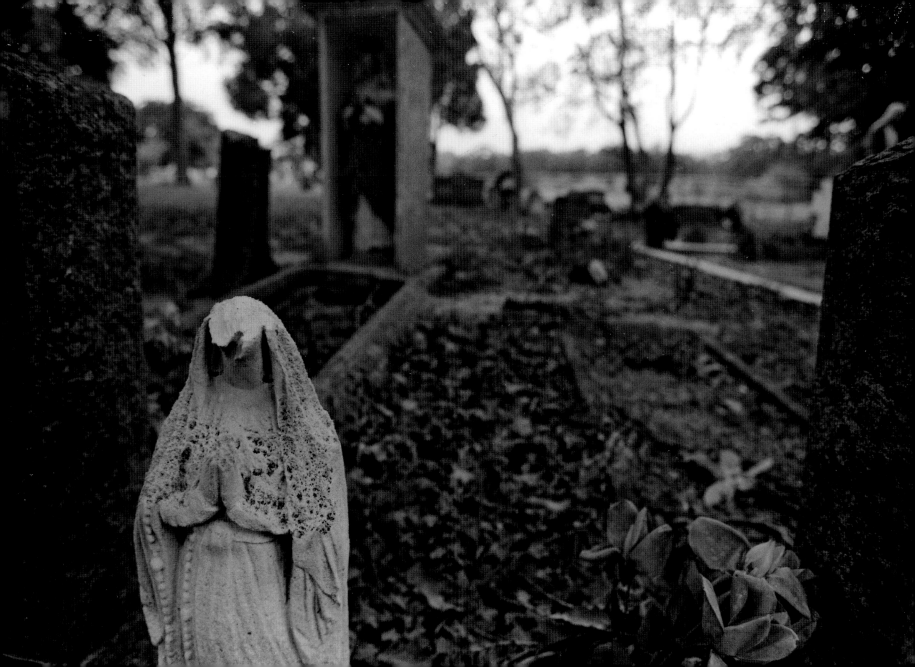

Broken Whispers and Dying Laughter

Drive along any Interstate highway in the Southwest and you might see a cemetery off in the distance. The view is familiar: an expanse of green with tombstones here and there, often in uniform rows, especially if it is a military cemetery. Once in a while, however, you might see an abandoned-looking cemetery with crosses all awry and headstones of bewildering variety. You may have just seen a Mexican cemetery. You glance once or twice, and drive on.

Bruce Jordan stopped at many of these cemeteries. He presents what he saw with his discerning eye and with his camera. Paradoxically, Jordan's *En Recuerdo de* is a collection of photographs about life, not death. These photographs show how one culture, the Mexican or Mexican American culture, has historically dealt with death in a positive and dignified fashion, even though the funerary practices we see here may seem strange and different.

The cultures of the world are varied, and so are the rituals and practices surrounding death. Even burial practices, however, have been threatened by the many forces of "progress" and moderniza-tion that have become constants in the sense that they usually stress efficiency and uniformity at the expense of diversity. This volume graphically illustrates the beauty and poignancy of Mexican cemeter-ies, and the aesthetic force, as it were, of a threatened culture, of a threatened way of life. These cemeteries are in disarray throughout much of the American Southwest.

Two main types of cemeteries developed in the United States in the nineteenth century. Early on, the churchyard was the historical site for burials in a tradition that dates back to medieval Europe. As the United States expanded, however, by 1835 a new type of cemetery had developed: the rural cemetery. Usually located on the outskirts of early nineteenth-century towns, the rural cemetery presented an inviting pastoral scene. There was usually much shrubbery in this type of cemetery, with trees, flowers, and quiet paths where one might contemplate the dead.

By the mid nineteenth century, after the American Civil War and as the United States expanded and urban areas became crowded, the

rural cemetery began to give way to the lawn cemetery. Lawn cemeteries originally were located away from towns and cities. Eventually, however, as urban areas extended their boundaries, they became incorporated into a town's boundaries. In general, after 1900 cemetery design moved in the direction of minimal decoration. There were, of course, many exceptions to this trend. Church-connected and rural cemeteries still exist in America, but urban population growth and a subsequent growth in death rates has led to increased use of lawn cemeteries with their vast expanses of grass, absence of Greek decorative motifs, memento mori, individuality, artwork, and any kind of ornateness. By the 1940s and beyond, some lawn cemeteries, such as Forest Lawn in Hollywood, became famous for the well-known persons interred there. To be sure, such a cemetery has its own austere beauty, especially with wide expanses that are pleasant to behold. The lawn cemetery, often regulated by private or public-private consortiums, is the most common kind found in the United States today, and there is no doubt the prevailing uniformity of this type of cemetery reflects the needs and urgencies of an advanced industrial society. Nothing could be more different from a rural cemetery or a lawn cemetery than a Mexican *camposanto*. A *camposanto*, literally "holy ground," is a Mexican or Mexican American cemetery. I have seen and visited a number of them, especially in my home state of New Mexico. Sometimes these cemeteries are not easy to find though they are common sites in the rural, heavily populated Mexican American areas of the Southwest. In the cities they are often bypassed by Interstate highways, or cut in half or isolated by urban construction projects. They tend to sink into

neglect and abandonment as the communities that supported them are gradually absorbed into the hustle and bustle of American life.

Look for a moment at the photo on page 66. Instead of a slick, mass-produced headstone, this gravemarker appears rough hewn and has a niche (*nicho*) carved out of it. Someone has placed a small statue of the Virgin Mary, propped up awkwardly, in the niche. A grave like this is overwhelmingly personalized, intense, and sincere.

These Mexican cemeteries are *different*. Crosses lean every direction (pp. 48, 51, 52, 67, 78, 120). Decorative elements have either fallen over been knocked down, possibly vandalized. The photo on page 25 shows a stone angel that has fallen over on a shattered and decomposing grave. It is slowly returning to earth as the angel with spread wings seems to be trying to protect what is buried below from the living, who do not understand. One of my favorites (p. 41) depicts a tin-covered cross. It seems that the maker of the cross was concerned that the basic materials used, brick or possibly cinderblock, could not withstand the rigors of time, so he or she covered the cross with tin to strengthen and help preserve it a little while longer.

Brilliant flowers, most of them artificial nowadays, decorate the graves. And the crosses! They come in all sizes and shapes. No two crosses in a Mexican cemetery are alike. Some are made of wood, others of concrete, some of whatever materials are at hand, such as the radiator grave stone (p. 115) or the metal file used to form a cross (p. 73). Some are carved or etched into stone as in the photo on page 90, or made of wrought iron, as on pages 74 and 91. Regardless of the materials used, the decorative motifs are even more varied. They range from simple to elaborate crosses with many images surround-

PAGE 100

ing them. The crosses may have a small Christ figure that becomes brilliant in the bright sun (p. 100) or a Christ figure watching over a grave in a field (p. 56) or a cross hovering over a window (p. 103). While the mighty and the powerful of the earth may lie in imposing mausoleums, the poor and humble speak more eloquently from their small plots of land marked only by a fragile cross (p. 57) or a cross with a portrait inset (p. 53). There is a primordial mythic power in these crosses, and painters like Georgia O'Keeffe reflect this in their work. Even for a nonreligious person, a sense of holiness attends these cemeteries.

In a Mexican or Mexican American cemetery or section of a cemetery, each gravesite is marked by a tender, loving touch. Notice, for example, the gravesites of children (p. 29). Here a handwritten message, scrawled most likely by a parent or a close family friend, is impressed into what was once wet concrete when the headstone was formed. Each homemade gravestone or marker seems to say, "Here are the remains of someone deeply loved and never to be forgotten. Here with this handmade marker is a stamp of faith and remembrance for a person who was somebody. Not a number. Not a statistic. Not merely a paid-for entry in the local obituary column of a newspaper. Not a faceless, digitized location in a landscaped cemetery, but a person." The photo on page 31 highlights a small plastic toy that may have belonged to the departed child.

It is easy for us to forget that the European influence in the Americas, including funerary practices, definitely did not start with an east to west movement of people. Over two centuries before the United States became a nation, Spain conquered Mexico and sent parties of exploration and settlement into what would at a much later date become the American Southwest. In terms of cemetery styles, the Spanish and Mexican experience was somewhat different from the English and Anglo American one. To begin with, Spaniards came to the Americas fresh from military and cultural victories over Islamic forces. The Spaniards felt compelled to conquer and occupy the Americas for a variety of reasons. Among them was the urgency they felt to prevent Protestant powers like England from harvesting the souls of indigenous cultures. There was, then, a deep religious intensity in the Spanish enterprise. This intensity carried over into the presentation of the *camposanto* or cemetery in the churchyard.

There was a much older stream of civilization in the Americas that the Spaniards encountered. Among these ancient indigenous

civilizations were the Incas to the south and the Mayas and Aztecs in Central America and Mexico. The Aztecs in particular influenced Mexican funerary practices. One of the Aztec codices that survived the Spanish conquest, the Codex Magliabechiano, informs us about the celebration of Tititl, or the Day of the Dead. One of the illustrations in this codex shows a merchant who goes to his grave with everything he needs to continue practicing his business activities in the afterlife. With the confluence of Spanish and Mexican practices beginning in the sixteenth century, it is no wonder that Mexican burial sites have their own extraordinary character. At times, a Mexican grave may appear unusual, even harsh (p. 55), but almost always dramatic. Here, not one but two crosses rise out of a pile of stones that were, no doubt, laboriously gathered. For funerary drama, this is as intense as it gets.

El día de los muertos, or the Day of the Dead, is actually two days: November 1 and November 2. On the first day, Mexicans remember their dead children; adults are remembered on the second day. The Day of the Dead celebrations reveal the Aztec origins of Mexican funerary practices. Families gather at the decorated graves of their loved ones and celebrate with music, food, and camaraderie. Many families and street vendors, echoing Aztec practices, prepare sugar cookies made in the form of skeletons and coffins. You can sense the presence, and the joy, of family gatherings on the Day of the Dead (pp. 82–86). In the photo on page 82, eighteen members of a family are gathered around a grave. For Mexicans, the dead need not be alone. Even though the excellent American poet Miller Williams speaks of the dead as lying "unbelievably alone," if there is

any validity to the religious ethos then certainly the spirit or spirits of the departed must be cheered by the presence of so many family members in this photograph.

Death (la muerte) is a familiar feminine figure in Mexican and Mexican American culture. She is personified as a charming yet mocking entity. Outside a restaurant in Morelia, I once saw the sculpture of a skeleton dressed in all her late nineteenth-century finery, welcoming you to come dine. I thought to myself that only in Mexico does a laughing skeleton welcome you to a restaurant.

En Recuerdo de reveals to even the casual observer the richness of Mexican burial sites. These cemeteries, now often hidden in unmarked fields near desolate towns throughout the Southwest, are slowly fading away. They are a healthy reminder of the values we share with all cultures that we, too, might lose if we are inattentive and passive in the face of changes going on all around us. Many of these graves have handmade inscriptions (pp. 34, 42, 45, 107, 117, 119). Some are inscribed on wood, others are carved into stone. Those who remember the buried dead have lovingly touched and shaped with their hands the last artifacts indicating that here once was an unforgettable person.

While change is inevitable, it is understandable that we wish to subject it to our own sense of uniqueness and community, and ultimately to our own sense of whatever meaning we find in history. For over two centuries the idea of progress has dominated the Western world. However, as we may legitimately ask, if our connection with the past is forgotten or severed, what is this progress moving toward? One of the most significant differences between ourselves and ani-

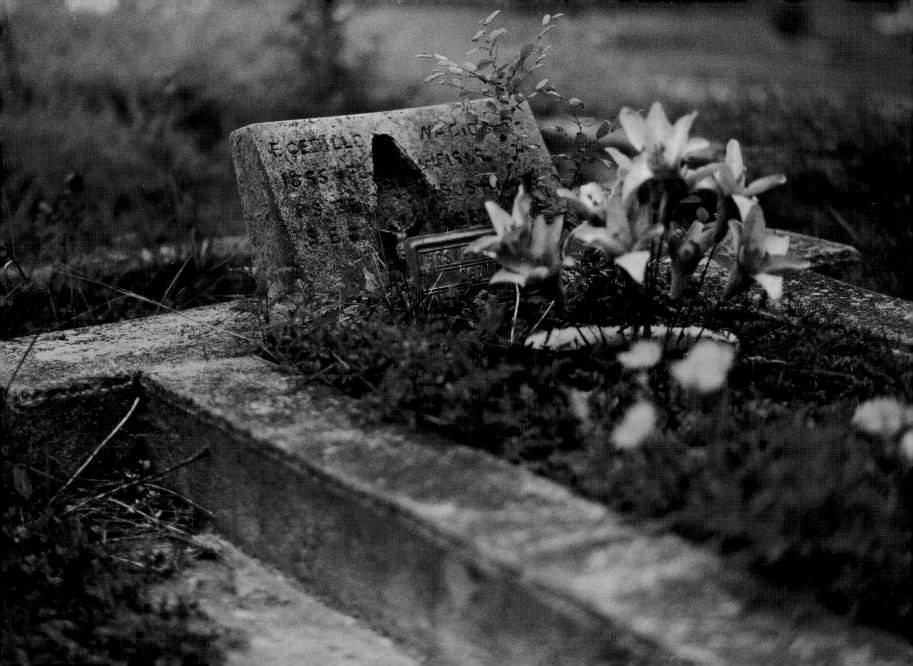

mals is that we have a history—a consciousness of the past of our species. While many animals run in a herd, humans tend not to do so unless we lose sight of our history. Mexican cemeteries form a cluster of artifacts that help remind us here and now of a past that was once a living presence and is a present moment that slips away inevitably into the past and into the future. These cemeteries help to remind us of our humanity, of who we are.

At the deepest level of the human community, literally and figuratively, are the dead. They inhabit a domain that often is neither understood nor appreciated. The dead, then, are somewhat akin to the poet described by Czeslaw Milosz in a brilliant collection of essays, *The Witness of Poetry*. Milosz argues that the poet, and I would add the dead, have experienced a radical separation from the premodern, prescientific, and mythic roots of art. Like Milosz's poet, the dead inhabit this strange world, our world, and barely notice the mythic infrastructure of history. In the absence of such concern, an empty chair in a Mexican cemetery (p. 59) becomes an arresting symbol of our time. In an imaginative leap, the chair seems to recall the now-absent loved one whose place can never be filled.

The living bury the dead and leave some expression of a living sentiment in the decorative art of the gravestone. Cemeteries have an uncanny way of capturing the spirit of a time and place in history. A few years ago I walked through the Montmartre cemetery in Paris. Many famous European personalities are buried there. The Montmartre cemetery looks like a distinct and elegant little city within the unique elegance of Paris itself. Listen carefully there and you might hear a broken whisper. Behind that broken whisper echoes the chatter of conversation in a Parisian street café, a fierce argument between artists and politicians on the Left Bank of the quietly flowing Seine. Listen carefully and you will hear a respect for, but not enslavement to, history.

When you walk through a *camposanto*, listen carefully. You might hear a broken whisper. That broken whisper will recall ranches and farms, open fields and an abundance of animal life, long journeys down the *camino real*, harsh winters, the promise of spring and new life. Listen carefully. That broken whisper will recall the large family, children newly born, robust and hardworking parents, and ancient grandparents all living under the same roof. Listen and you will hear a hard life, but also an abundant life, and dying laughter off in the distance. If you listen and carefully watch as you pass by a Mexican cemetery, you might see a Jesse Martinez (p. 37) or an old man (p. 104), both of whom are very much alive and attached to their past, to their history, at the same time. I don't think it is so much a matter of the living being preoccupied with the dead as it is a case of the living being so full of life they want to bring the dead into it, insofar as that is possible. Spanish philosopher Miguel de Unamuno spoke of the *infrastructure* or deep current of human experience that ran beneath the passing surface phenomena of life. The faces of Jesse Martinez and the old man seem to reflect awareness of a deep connectedness between the living and the dead, between the past and the future. The present is a kind of illusion that forever recedes into the past while it forever advances into the future.

There are embedded social messages in many of the graves photographed by Bruce Jordan. In the photo on page 44 a hammer is set

into the concrete, perhaps a reminder of the work or the trade of the person buried there. This picture reminds me of another grave that Bruce and I saw at the San Jose cemetery in Albuquerque. It carries the inscription, "This man worked hard all his life." Even where an attempt is made to honor the dead on a grander scale, as on page 39, the mausoleums are remarkably simple yet distinct. Although made of concrete, whoever built them treated them as art objects: they are individualized and given character. For me, there is a strong echo here of Aztec, Spanish, and Mexican craftsmanship.

We have much to learn from the Mexican cemeteries. Our world, on a global scale, has become increasingly uniform, yet some elements of cultures still resist homogenization. Take, for example, the enormous variety of crosses found in Mexican cemeteries (pp. 46, 60, 64, 69, 108, 128, 158). The photo on page 128 is very curious indeed. There is no way of knowing whether or not the person who constructed this grave intended to set the cross in such a way that its shadow would be cast upon the grave by the sun in its daily course through the sky, but the effect is powerful. Every day this special shadow cross travels across the grave as a reminder, in a religious sense, of the life to come. And where else in the United States are you likely to see a dog on a cross (p. 81)? The dog may have been a pet, or one that had some unknown special meaning.

I am not making a Romantic argument here in favor of turning back the clock. Individualism is important. But a rich life is generally nurtured by community, from the family on up to more complex forms of social integration. Art, music, literature, and certainly the popular arts spring from community. At a basic visual level, what we

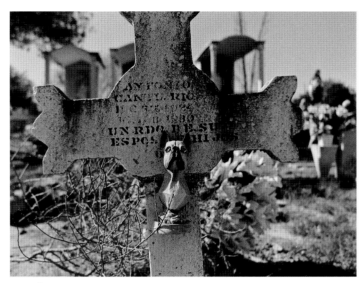

PAGE 81

see in cemeteries, in *camposantos*, when viewed as a kind of popular art, or lack of such art, really does reflect how we value life.

Recently my father, the last of my parents, died. He and my mother lie buried in Mount Calvary Cemetery, one of the older cemeteries in Albuquerque. Today, the modern section of the cemetery is a bland lawn expanse. There is, however, an older part of Mount Calvary. All records for this earlier section disappeared in a fire years ago. So all that is left now is memory and the oral history about those who lie there and the broken whispers of the dead themselves. Among them is my grandfather. I remember approximately where his grave used to be, having long since disappeared. He was a musician. Among the broken whispers I hear the faint echo of his violin. It is a pleasant

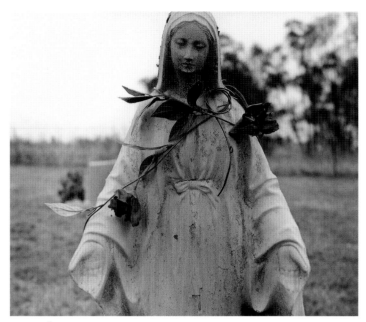

PAGE 146

even brighten the outlook of nonbelievers. For sheer aesthetic joy it is hard for any image to compete with the Madonna with flowers (p. 146, left). The Madonna, even though cast from a mold, is beautiful. Someone had the artistic insight to magnify her beauty with the plant entwined around her shoulders. The crosses at Terlingua (pp. 49 and 95) remind me of Golgotha. It is easy to see this Southwestern Golgotha, like its original, as a dark place, a reminder of suffering and death. Less obvious is the sun rising and setting on these crosses as they point upward at all times toward heaven, beyond defeat and death. In the photo on page 93 we see a striking cross made from the simplest of materials, wrought iron and wood, and a simple garland of flowers. The light reflected off the wreath cries out with optimism about life and the human condition. You sense that somewhere out there in the light children are laughing.

Laughter has a way of never dying. Laughter disrupts solemn proceedings. It deflates stuffed shirts. It reminds us of youth, rebirth, spring, and all lighthearted things that sing and dance beneath the sun and moon. Listen carefully and you will hear laughter in these old camposantos. The old ones are laughing at our furious efforts to pour asphalt and concrete over every available acre of land on the planet. They are laughing at our frenzied lifestyles, which we think are so much better than those of the past. Above all, they are laughing at us because we take ourselves so seriously. We have so much to learn from the old Mexican cemeteries. They teach us that broken whispers still tell the truth, and dying laughter, like truth, has a way of springing to life again, of bringing us back to our true selves.

music. It says that beyond the broken whispers there is the laughter of people, the young and the old, gone to dust long ago.

There are so many outstanding images in these photographs that it is difficult for me to select my favorites. Nevertheless, I will make the effort. Jesus and the lilies (p. 80) dramatically presents a theme of life and death and the cyclical nature of life and death. Over the grave hovers Christ on the cross, the dying Christ figure who also represents the hope of resurrection, of eternal life. On the grave itself lilies are growing, as if the life force cannot be repressed, not even by death. The lilies, in effect, echo the religious theme, and perhaps

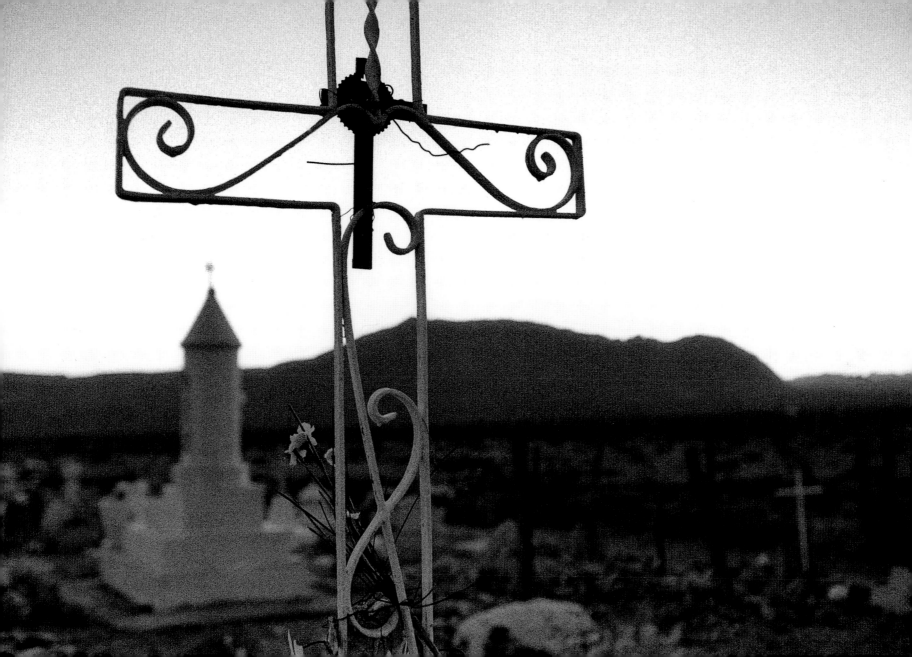

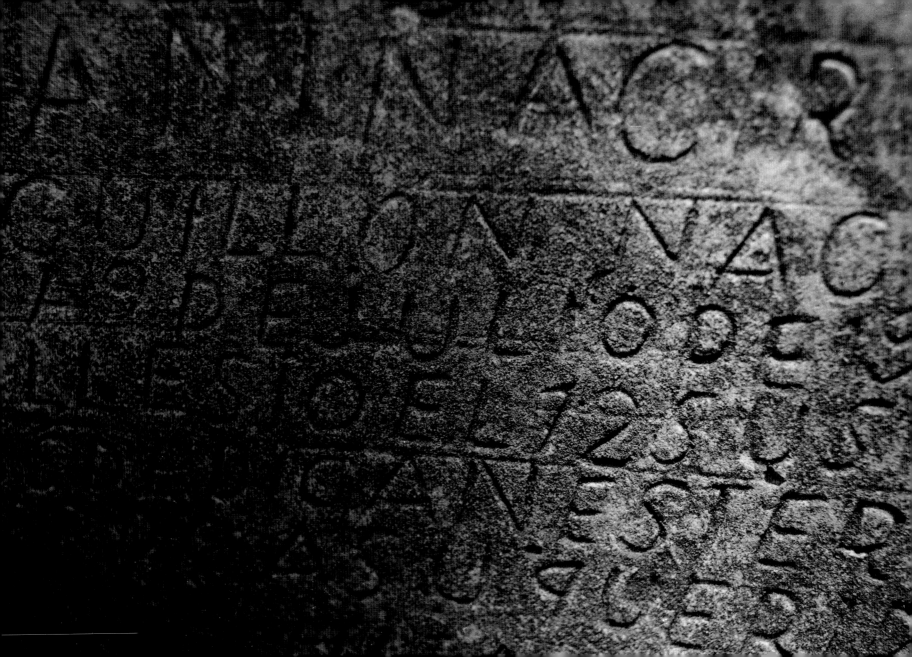

Photographs

"The ingenuity is limitless. The love is still clear. . . . It is the craftsmen who have offered their personal styles and who have made each place special through the work of their hands and the love in their hearts" (p. xiv).

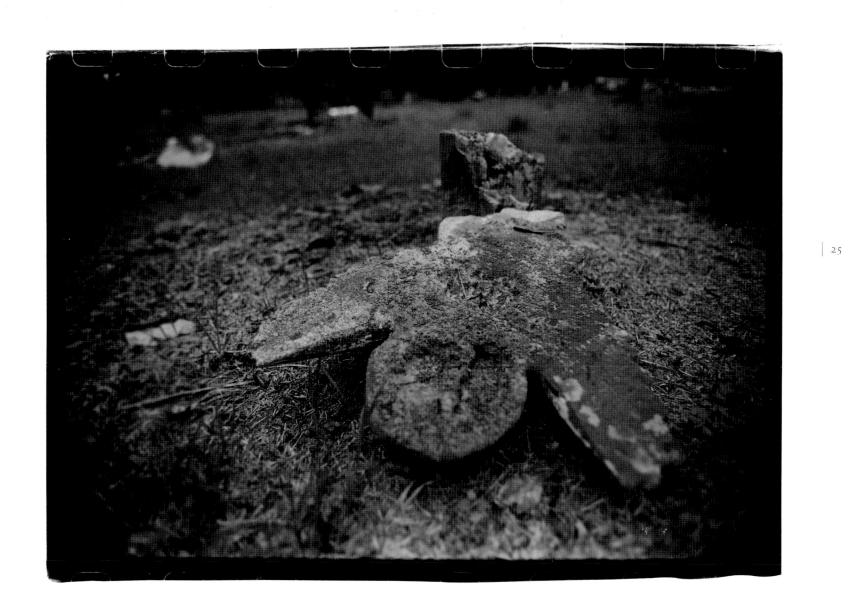

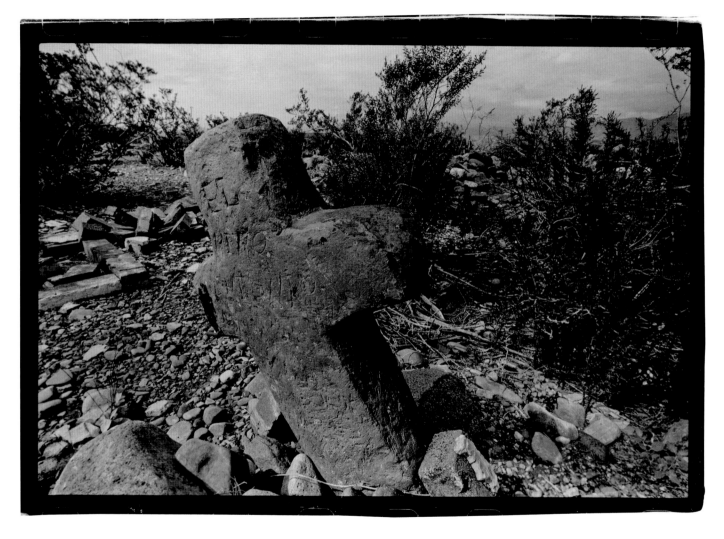

How hard life must have been? What was left at the end of that life?
Scratches in a rock that had been hammered, chiseled into shape?

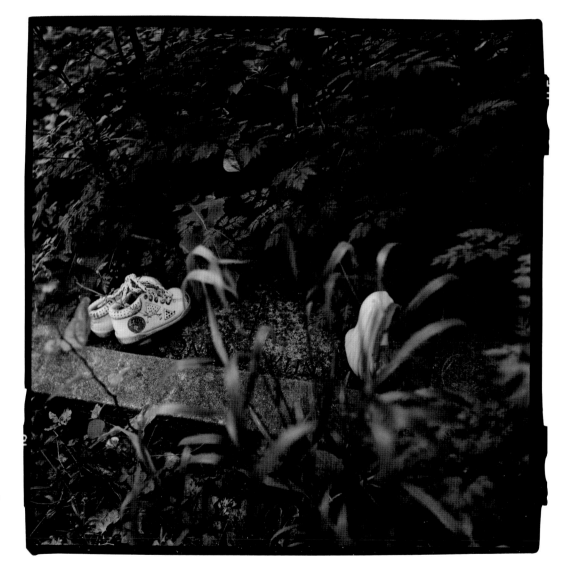

Seeing the small shoes, not just small figurines or toys, changed things. The imagination can see the child in the shoes, walking through the house, playing in the yard, running herky-jerky as a child does when learning about how legs work. I imagine putting the shoes on my son's small feet and teaching him to tie them. Then things changed again.

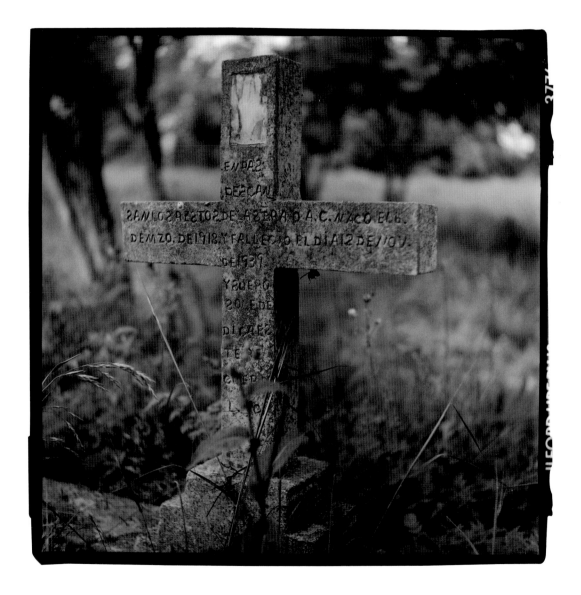

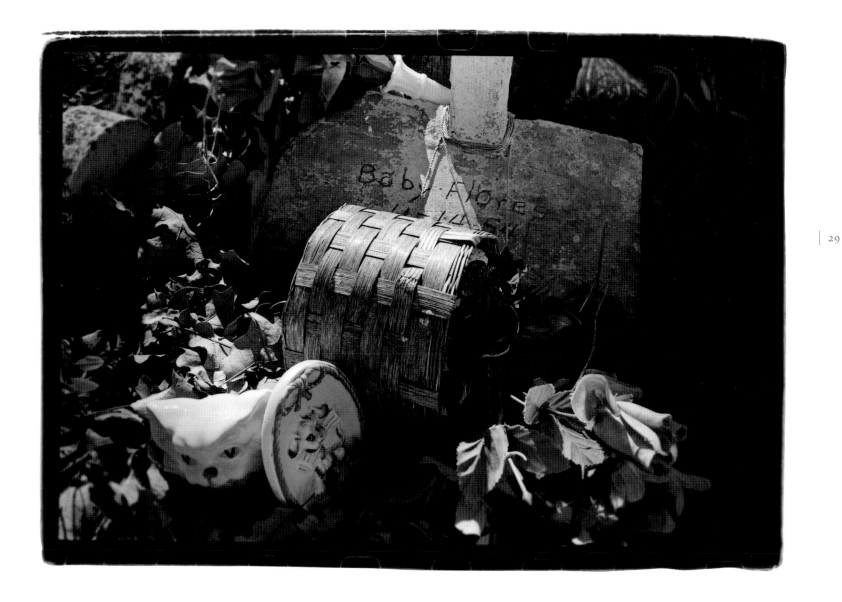

A series of small graves stair-step their way up the hill toward the fence. A figurine of a child holding a puppy and pulling a wagon full of puppies rests on the corner of the heaving stone. The children's graves are separated from the other graves, both individual adult and family plots. I wonder why. Is this a way of making sure the children, their graves so small, do not get lost? Is it a way to pay special attention to them, or make it easier for Jesus to find them?

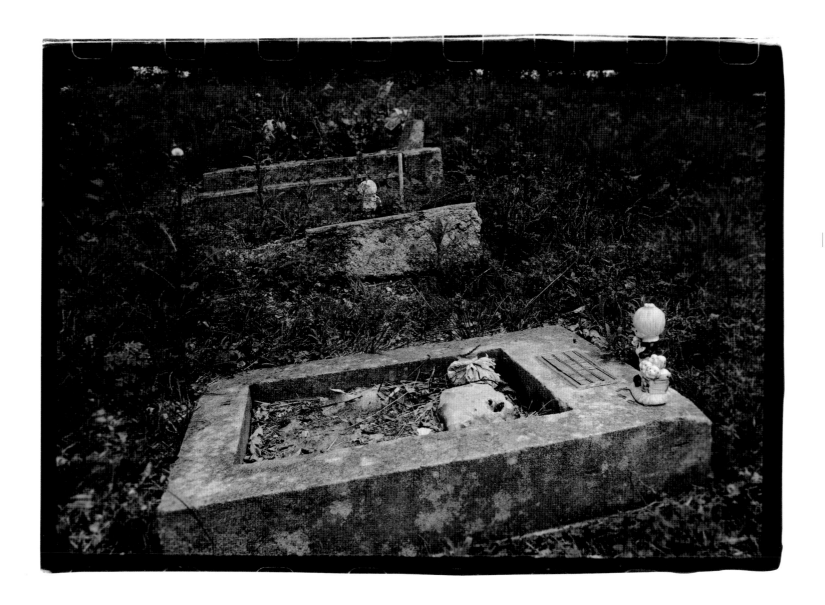

Bernardo's shoes are hanging up for him, ready for use when he is. Elders surrounded this small child. Who is there for him to play with?

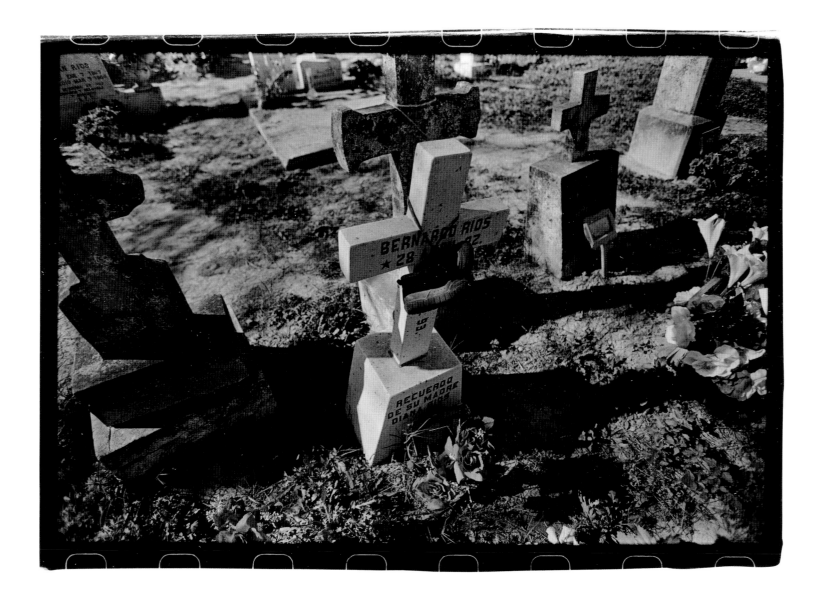

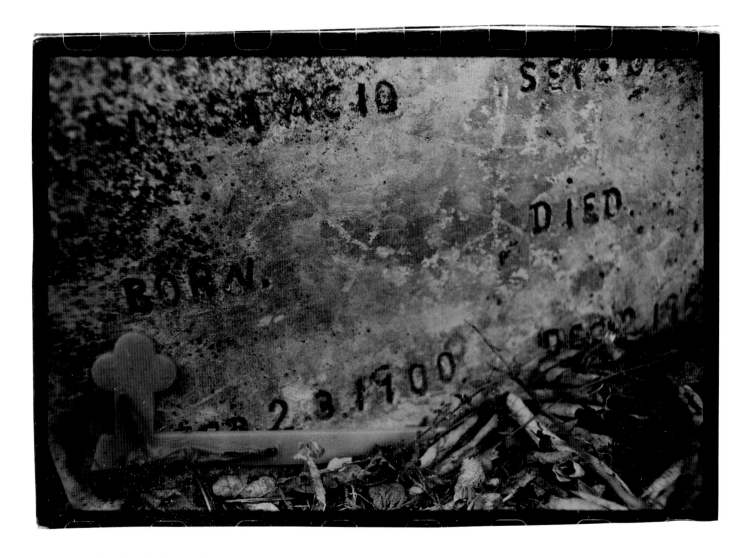

Anastacio was born long before this plastic cross existed. Jesus existed long before
Anastacio. The stone existed long before both. Who will be left to visit Anastacio?

Martiniano's Story

Jesse Martinez's grandfather, Martiniano Garcia, was born in Mexico in 1880. In the early 1890s, Martiniano came to the United States, along with his mother and two sisters. They walked across the river from Mexico, making their way to San Marcos, Texas.

In San Marcos, Martiniano farmed cotton as a sharecropper. In 1895 he sold his first crop for 50 cents a pound. Martiniano moved north to Austin, where he lived for seven years. He was one of the founding members of the Mexican cemetery in south Austin, Maria de la Luz. A young girl had died and the community had no place for her to be buried. Martiniano and others came together to create the original cemetery organization.

Martiniano moved on to Rosebud, northeast of Cameron, Texas. Again, he was a sharecropper, producing the first bale of cotton in the area. In 1929 and again in 1936 Martiniano bought new cars, after having walked across the Rio Grande over thirty years earlier.

Martiniano became the patriarch of the Mexican community in Rosebud. He was trusted by the community and helped solve disputes, said Mass, baptized children. When priests came to say Mass once a month, Martiniano and his wife, Caritina—who was born in Monterrey—would hold lunch for the priests and community on their front porch, with everyone pitching in. He was also the postmaster for the community. Martiniano had taught himself to read and speak English by reading and studying the local newspaper.

Once again, the Mexican community needed a cemetery. Martiniano bought land to use as the cemetery. He allowed people to bury their dead for free but they had to help maintain the grounds. To raise money for maintenance he would accept cash but also bartered to help raise funds. Whatever a person could offer, a chicken perhaps, was accepted in payment of the individual's responsibility to help take care of the land.

Jesse Martinez and his wife, Frances, have seven children and fifteen grandchildren. A close family, all of their children graduated

from high school. It was a long walk from learning English by reading the newspaper. And all have pursued education beyond their high school diploma, with all but one attending college.

Jesse is now the patriarch of the family. We met while he and his grandson, Kaleb, were cleaning the cemetery one Saturday afternoon, rake in hand. Jesse tries to keep the younger members of the family and community, those who haven't moved off to pursue opportunities and careers that stretch beyond Martiniano's imagination and his long-ago walk across the river, involved in caring for the cemetery. It is important to maintain the legacy.

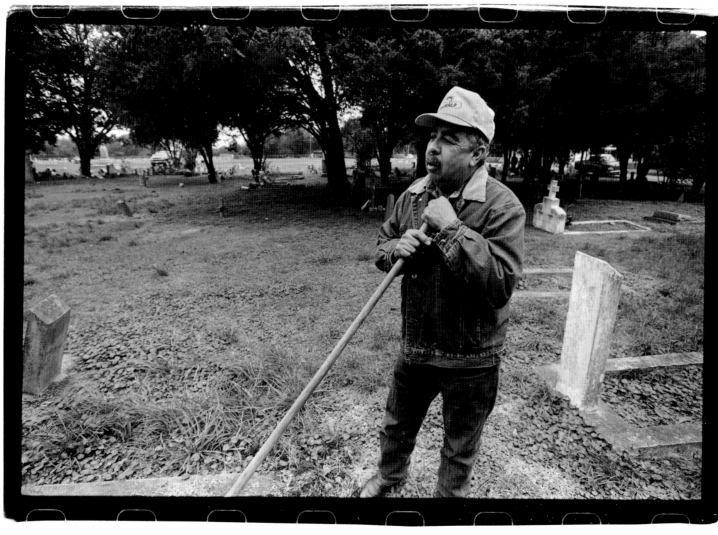

Jesse Martinez

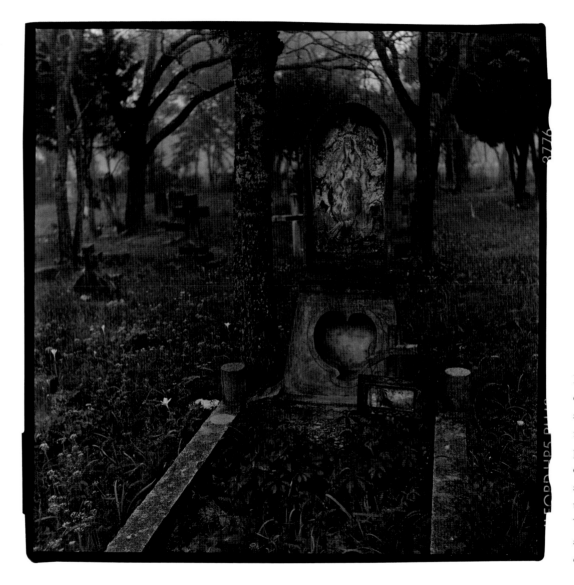

Fog softened the image in front of me, adding to the questions and wonder and mood of the morning. Perfect for this kind of place, for a photographer seeking emotion through his lens. I feel as if at any moment the dead will talk to me, tell me their stories. White flowers in the gray light add accent to the large headstone of Inmaculado Corazón de Maria.

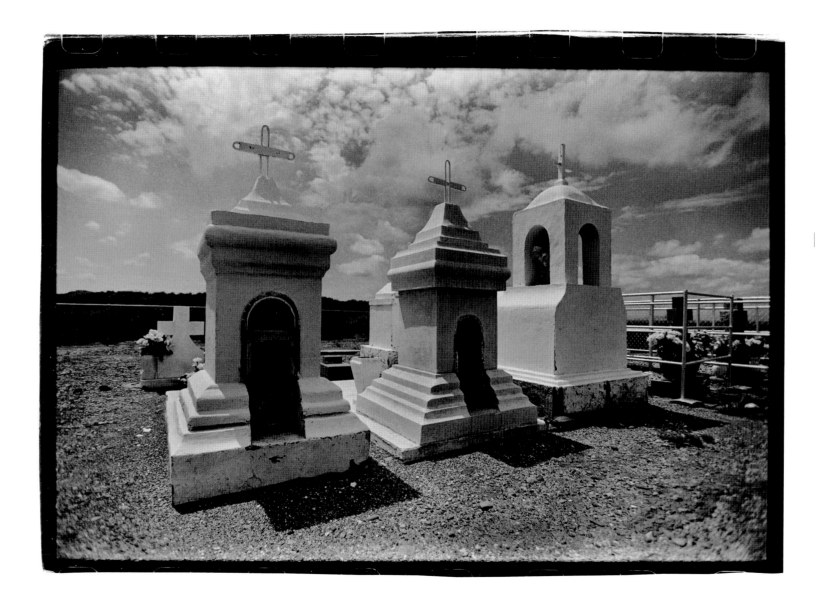

I am struck by so many of these constructions and the variety of solutions for lack of money. The cross of tin or sheet metal wrapped around and nailed to a core of wood fascinates me. Clean, unadorned, and elegant in its simplicity. The hammer still sounds in my imagination as the maker bends the metal around the wood then wraps plumber's tape around the top to secure the metal one final time. Was the metal just scrap or was metalwork the trade of the maker?

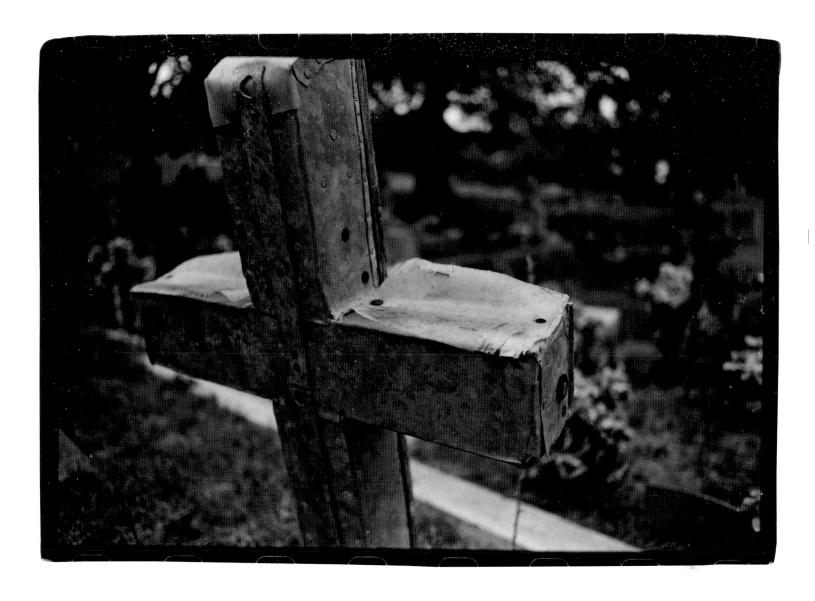

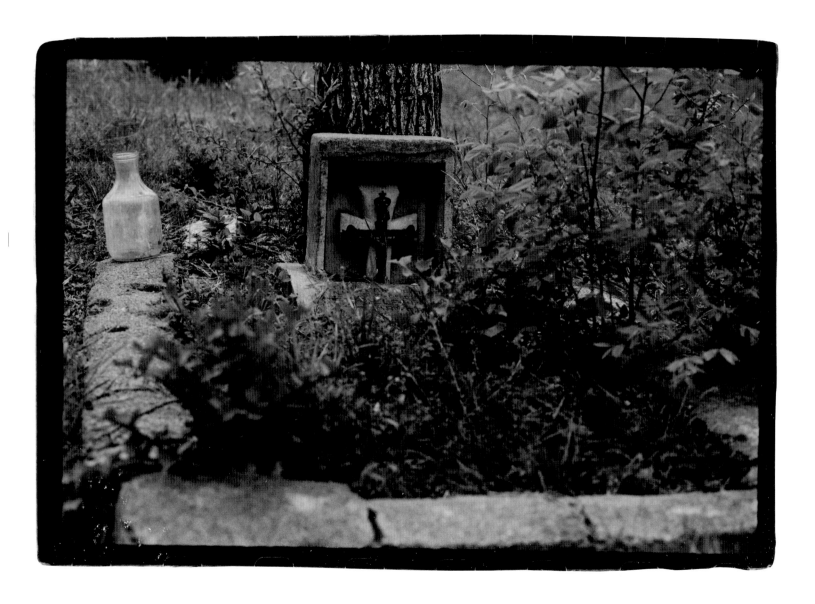

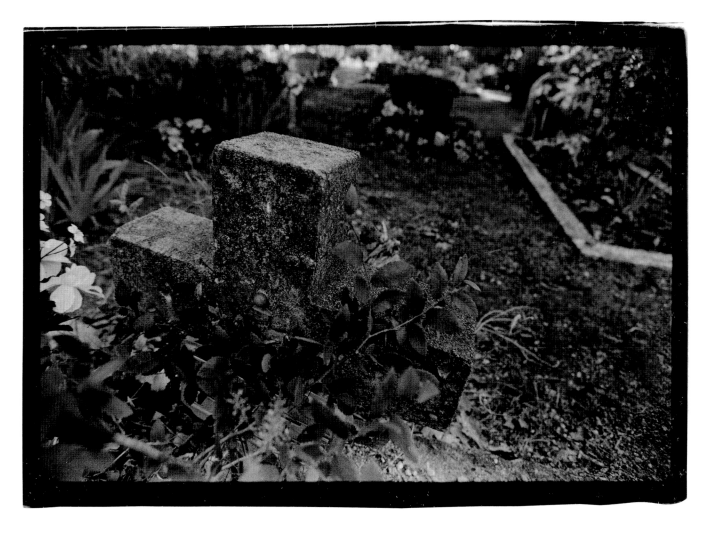

Marbles used as decoration have fallen away. A small cross is almost hidden by the leaves. Who was this person? The
name can no longer be seen as the cross has sunk into the ground and the leaves and grass have grown around it.
Small details can be missed if one doesn't take the time to kneel down, slow down, and look closely, in death and in life.

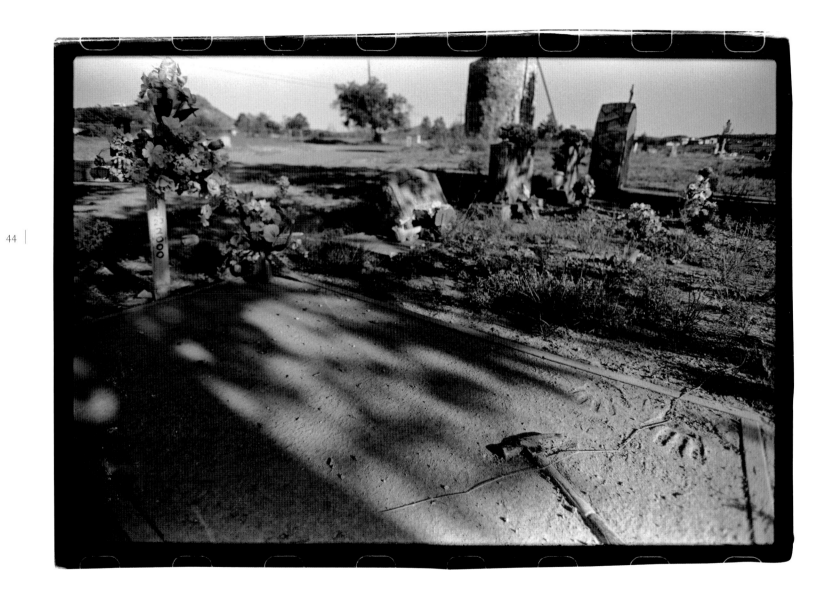

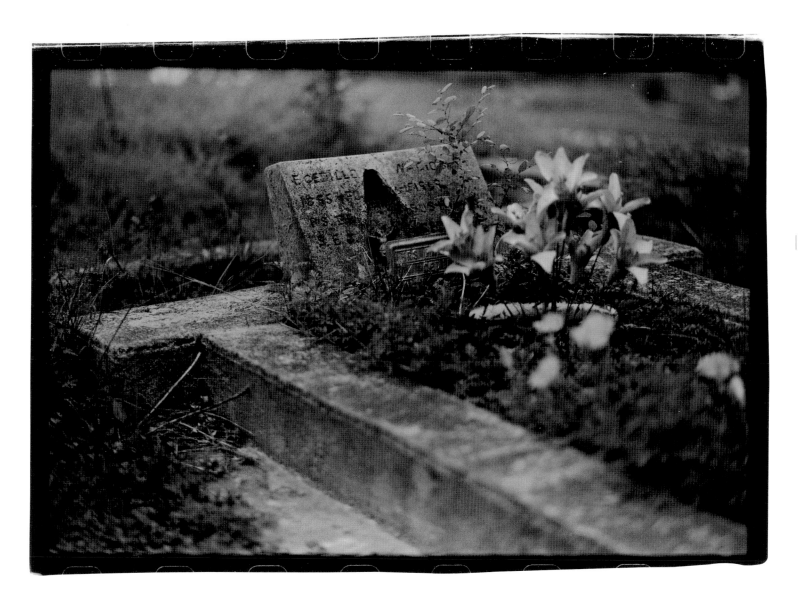

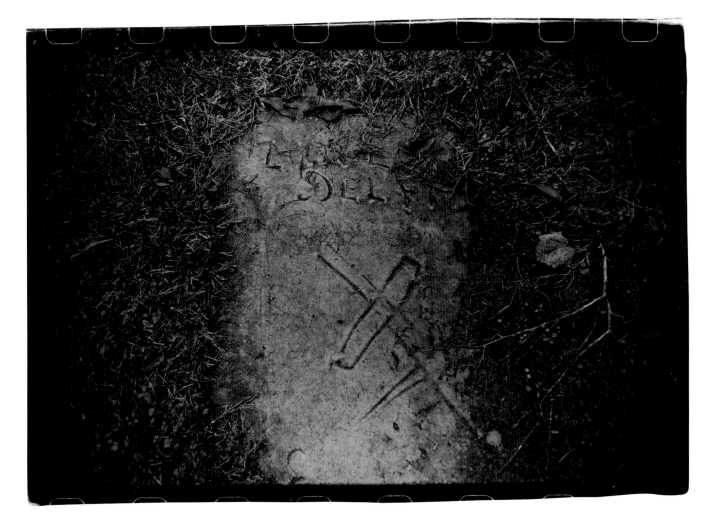

Flat on the ground, the slab is both remarkable and sad, and nearly invisible. The grass has grown over the edges of the worn, glass-smooth concrete with the patina of decades of wear. A finger must have been used to write the name and draw the cross. There are no flowers, no photographs, nothing. The stone almost disappears among the larger headstones.

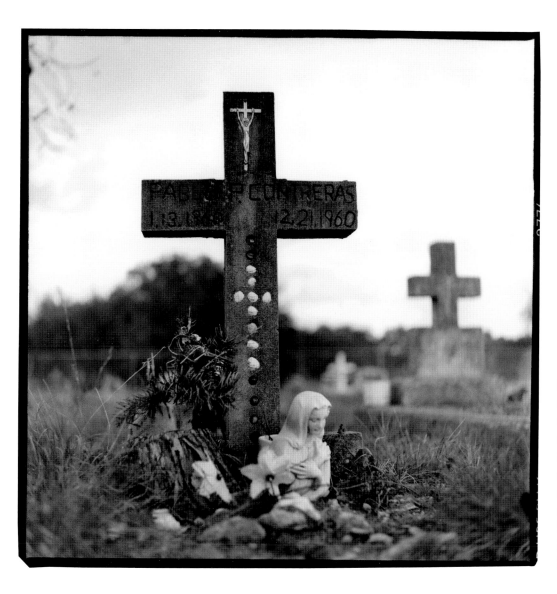

Simple yet elegant in its simplicity and balance, the shells and marbles have been carefully counted and pressed into the concrete. Shells are used to decorate tombs around the Mediterranean, a practice brought to the new world. The marbles? Both are used widely in these cemeteries north of the border. Small flecks of dark stone or glass surrounding the silver cross have been pressed carefully into the concrete like a small rosary. Even here, en el Norte, Jesus looks down from the cross onto the Virgin.

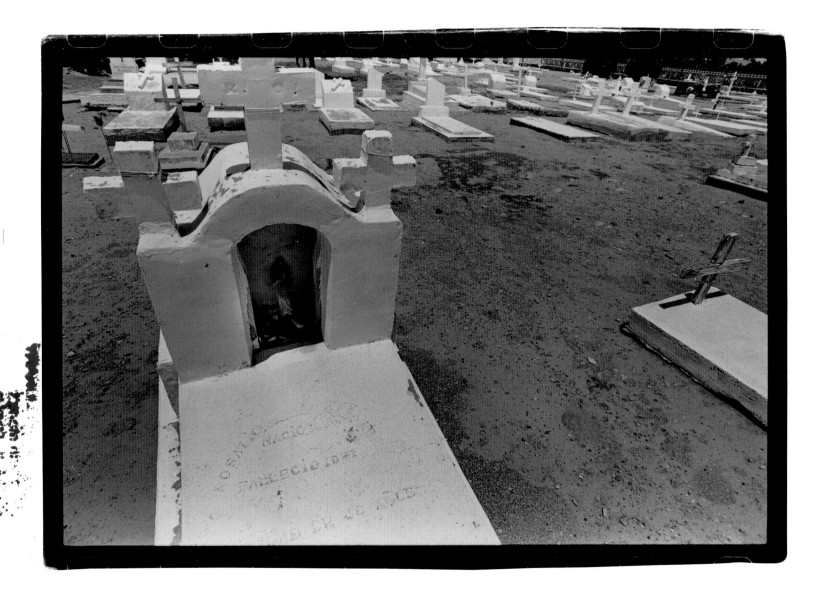

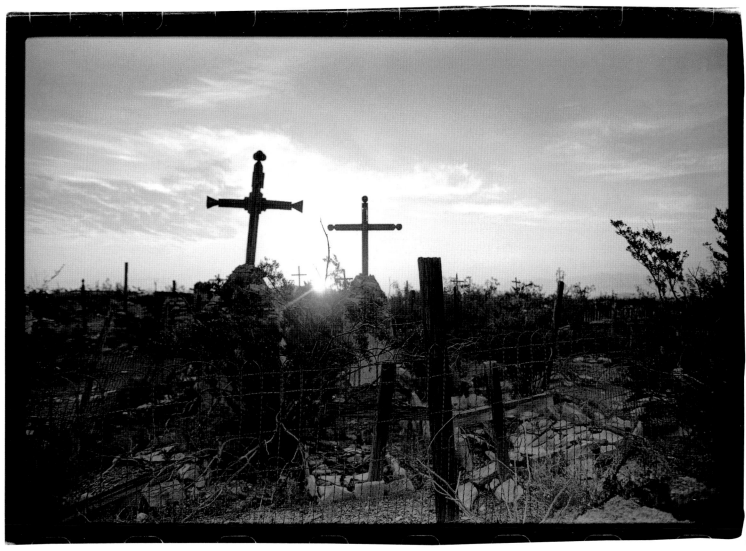

Piles of rocks lined up in rows point toward the mountains in Mexico, just across the river. The ground is too hard and rocky to dig any deeper. White crosses, made of concrete or wrought iron but mostly of wood, mark a few of the graves. Maybe these families had more money. Or perhaps a later generation came back and paid their respects. There are no names to declare who lies where, just the rocks and cacti. A lone wiry ocotillo stands in the dry desert as the only decoration.

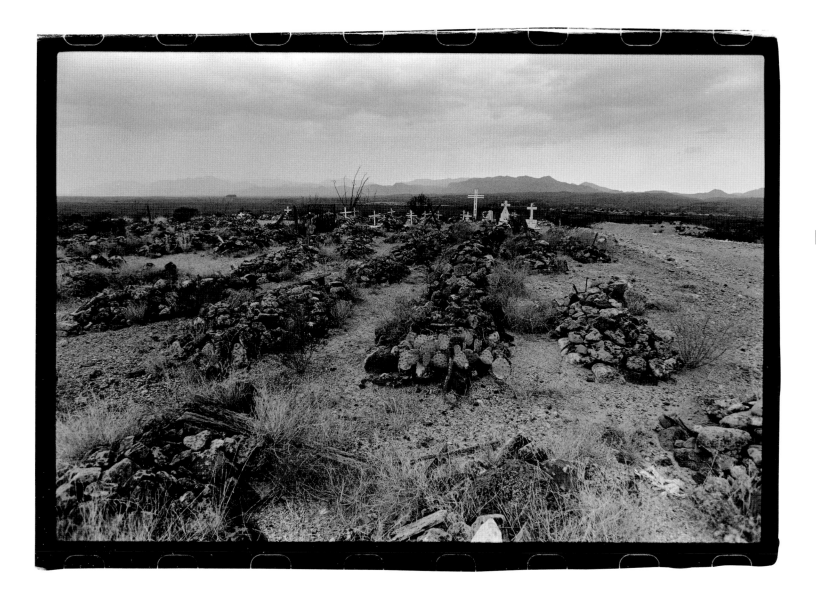

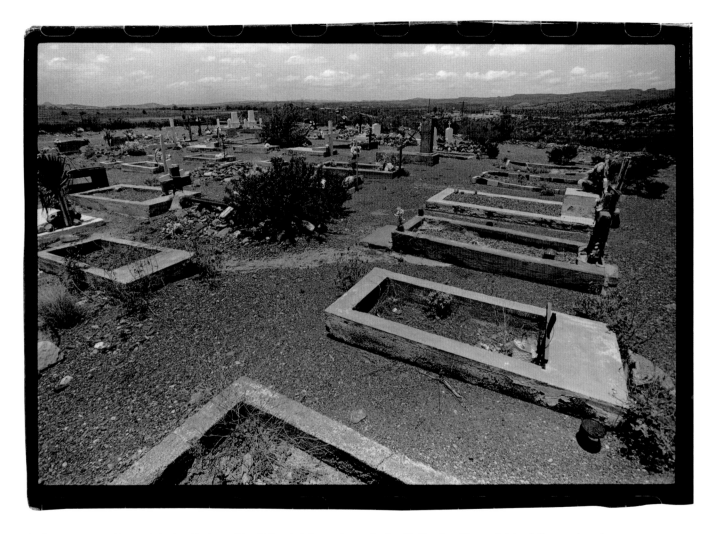

In the cemetery, and beyond, the land is dry and hard. The air is hot and completely still. Gently rolling and rising hills stretch to the horizon, with no human life in sight and even less water. It could have been a cowboy movie, the chase scene across the desolate land. But it isn't; it is real. Who labored to pour concrete borders when sand and rock are plentiful? Had they struggled this hard to live?

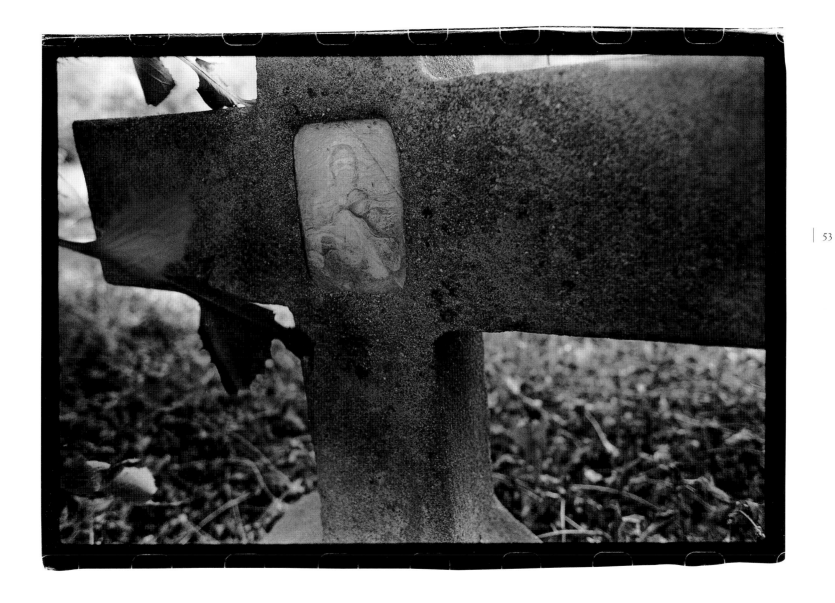

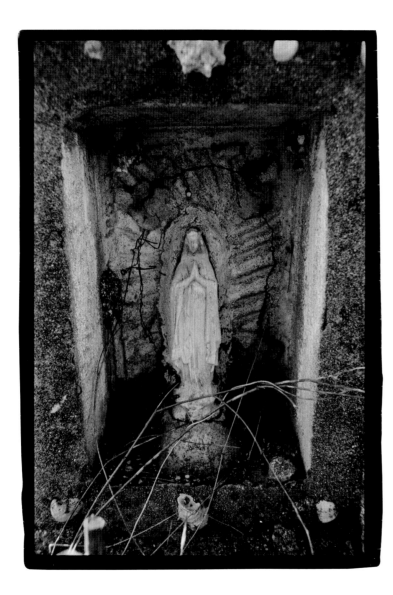

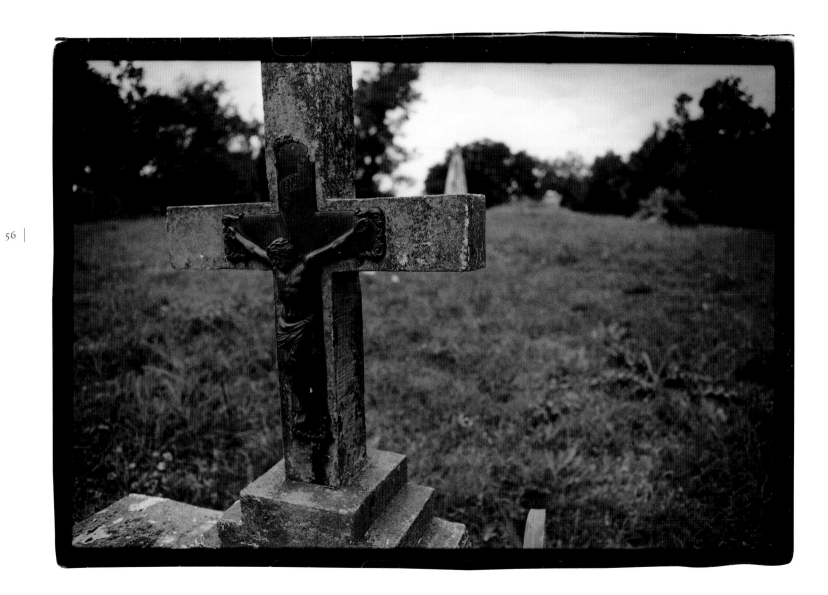

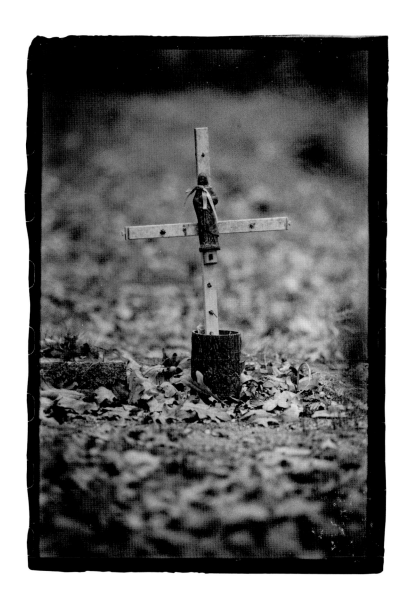

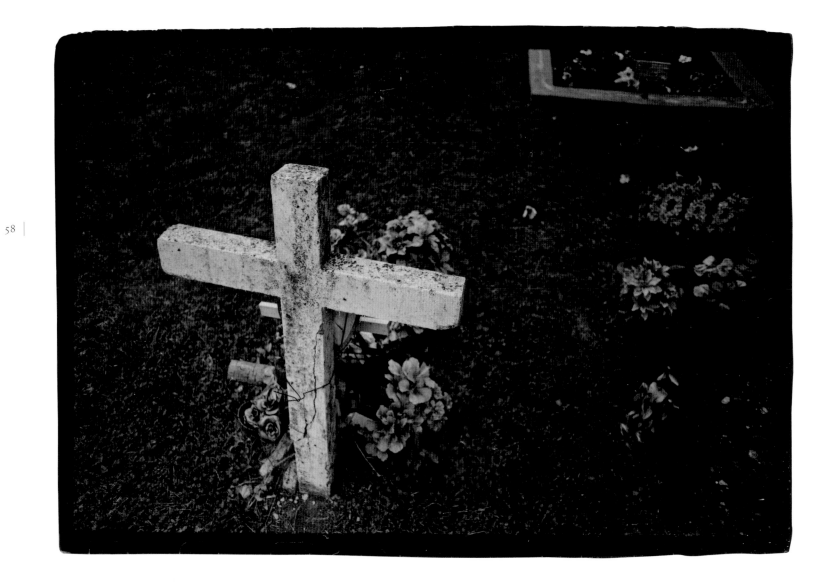

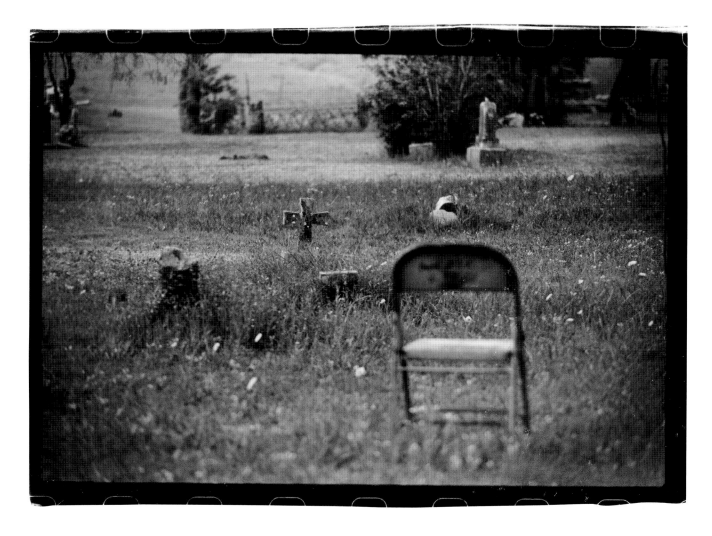

The chair sits in the middle of the large, widely spread cemetery. Not a bench, which is expected, but a folding chair. What is it doing there? It isn't next to a grave, where someone might sit when visiting. It isn't under a tree, where someone might sit in the cool shade and take time to reflect. It sits out in the open, out in the middle of all of that space, like another tombstone, slowly fading and rusting away.

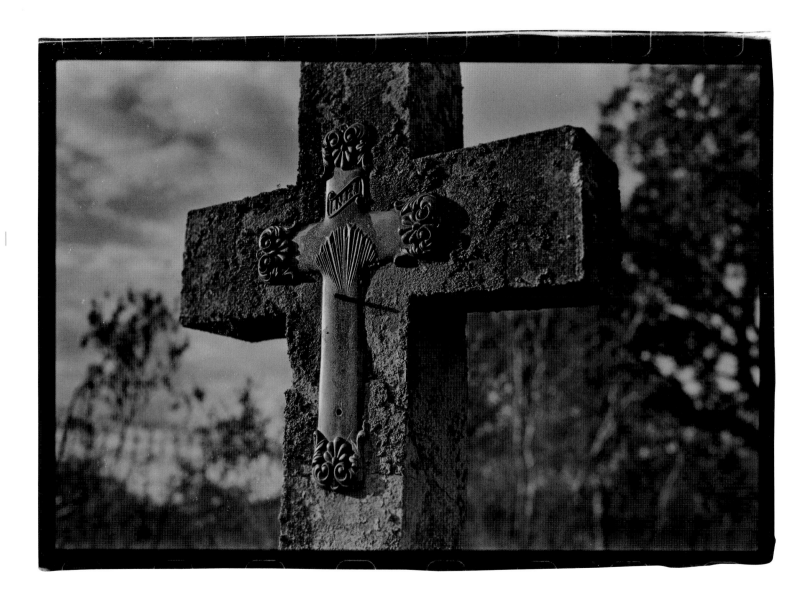

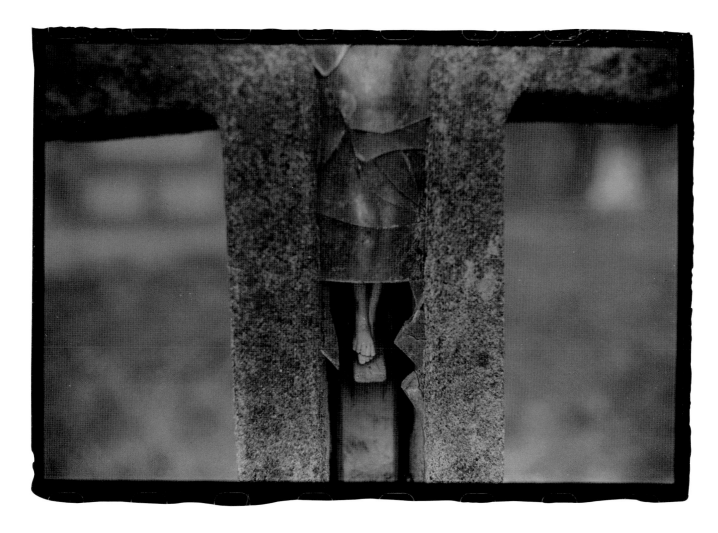

"And behold, a woman of the city, who was a sinner, when she learned that he was sitting at table in the Pharisee's house, brought an alabaster flask of ointment, and standing behind him at his feet, weeping, she began to wet his feet with her tears, and wiped them with the hair of her head, and kissed his feet, and anointed them with the ointment." *The Holy Bible*, Luke, Ch. 8, Revised Standard Version, AD 1952.

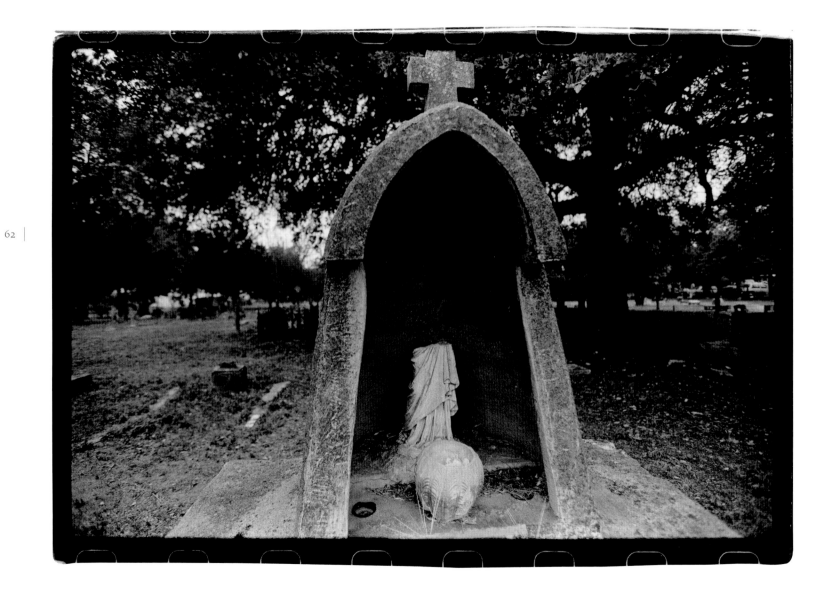

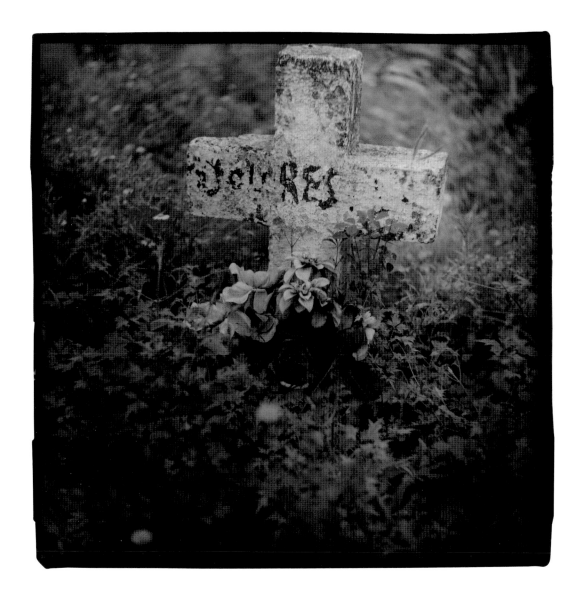

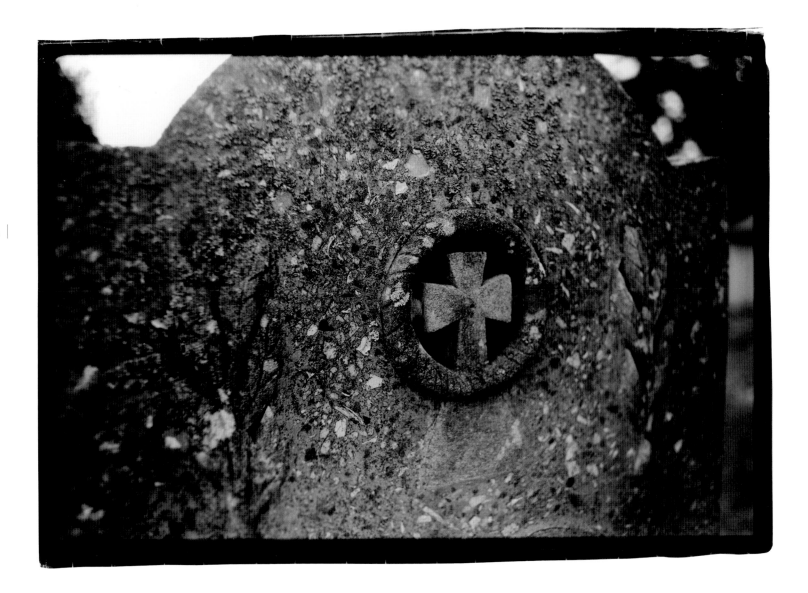

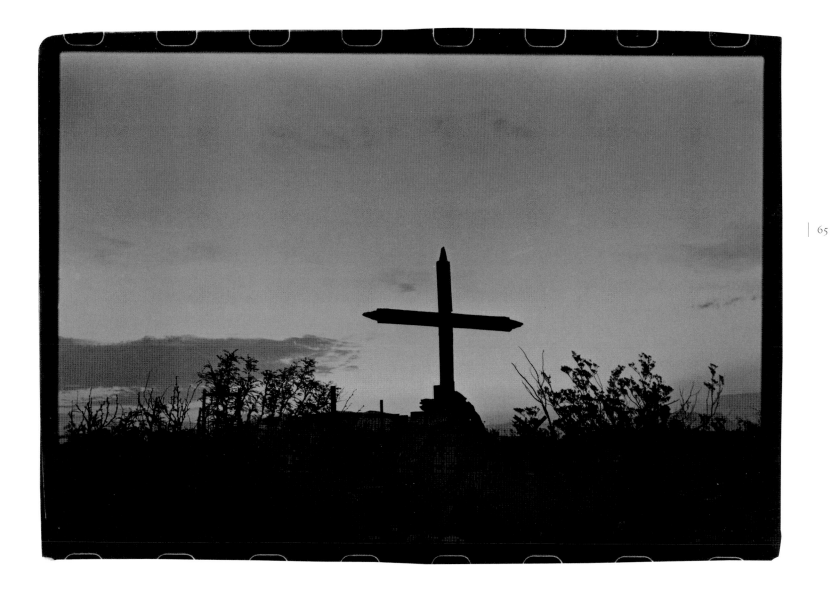

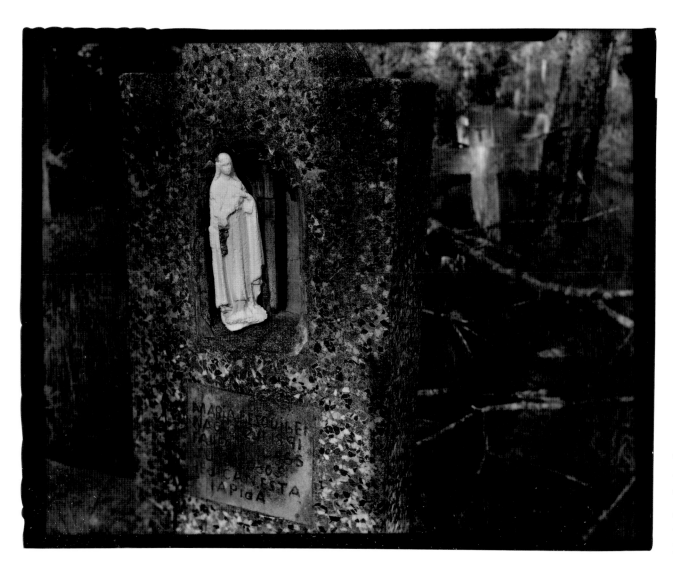

There was magic in
the light that morning.
The Virgin, and the
cross behind, seem
to glow with the
holiness of this place.

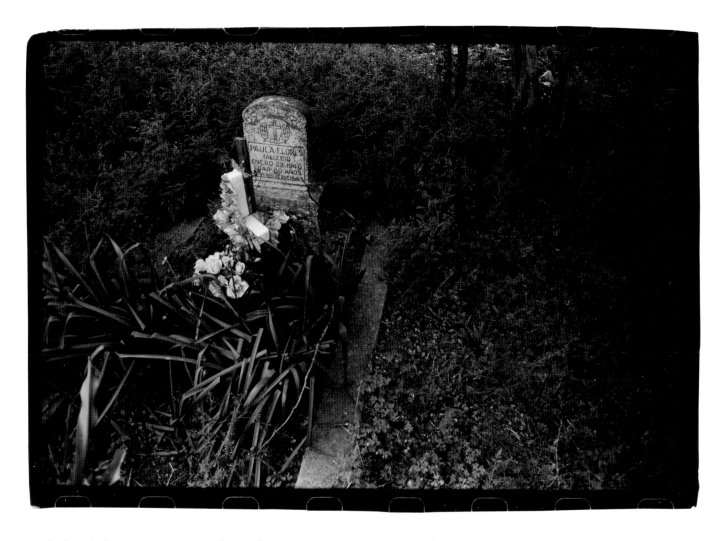

Paula Flores died on January 22, 1940, at the age of eighty years. Her grave sits in an area that is now overgrown. In the morning sunlight the tombstone glows among the darker leaves and shadows. The long leaves of the iris and lilies add a shimmering texture. A foam cross with white flowers seems out of place. Had she been born in this area or traveled with her parents from Mexico at the time of the Civil War?

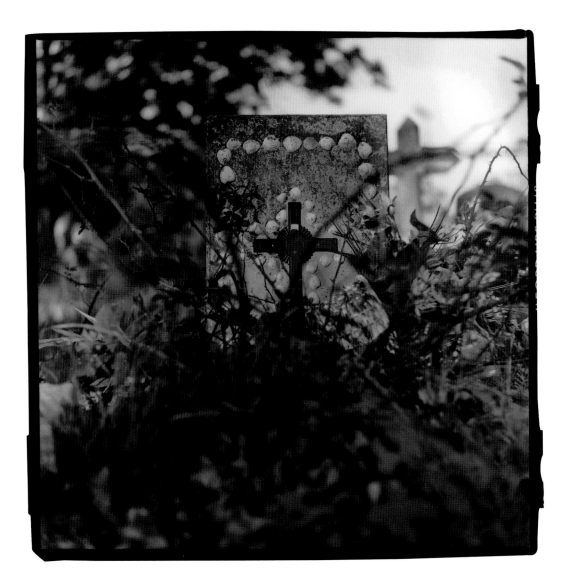

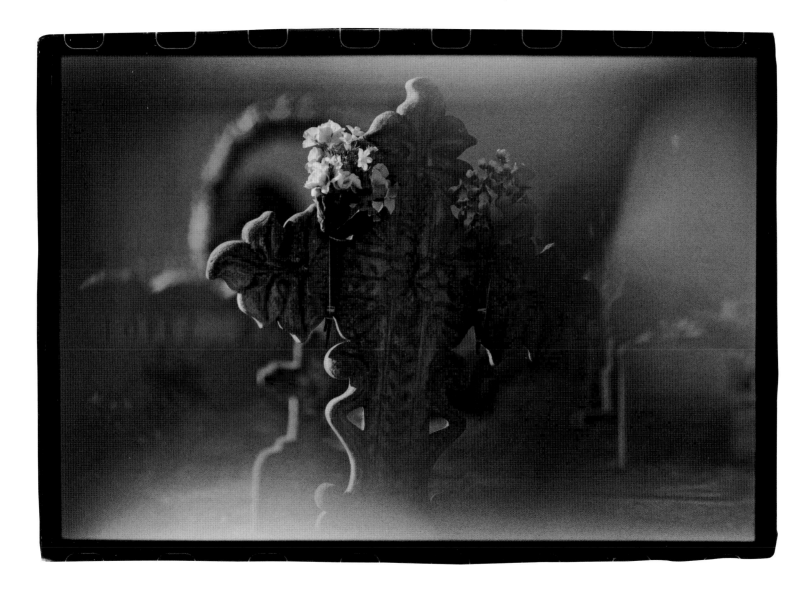

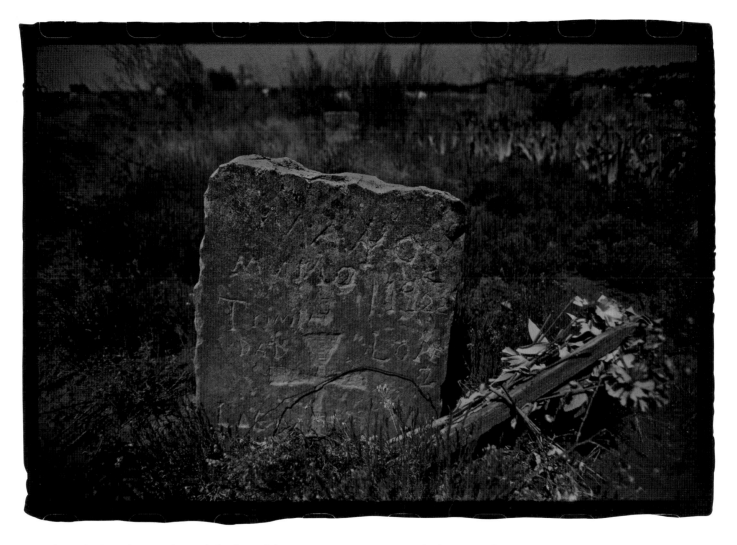

Dry plants, shrubs, and grasses that prick the skin and the ever-present irises are nature's landscaping in this cemetery above the small mountain community. The people are poor; only a few purchased headstones exist.

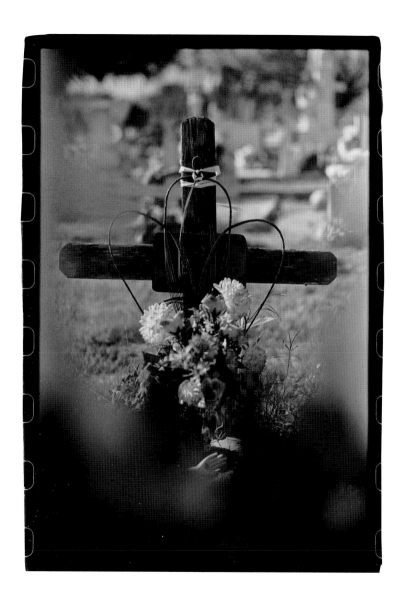

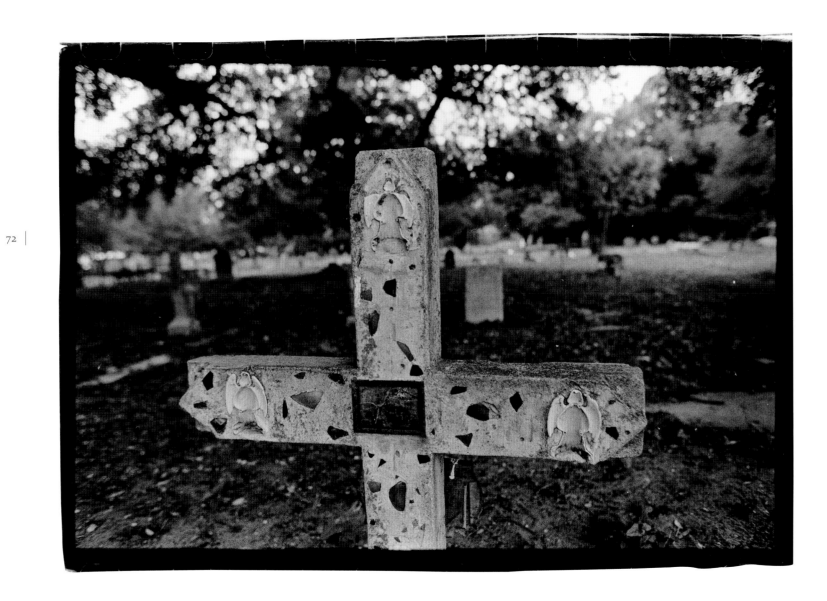

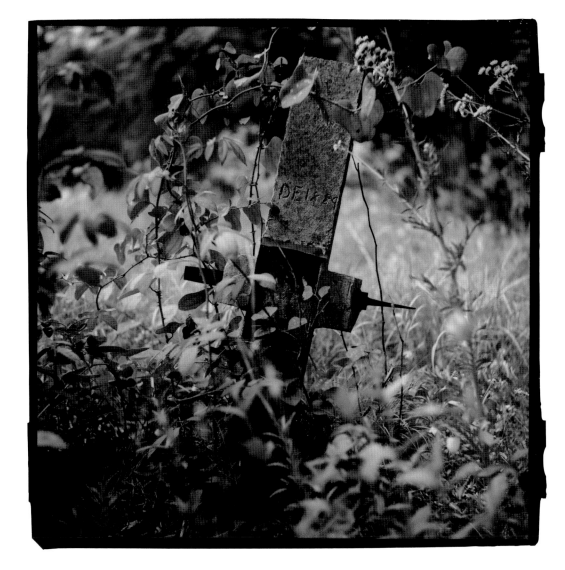

Mechanics, carpenters, folks who work with their hands, do not loan tools. Tools are not only part of their livelihood; they are part of their identity. I did not notice the file protruding from the remainders of the arms of the cross until printing this photograph. To give up a file, to use it as rebar, is a sacrifice. What deep respect for the deceased and the responsibility the maker must have felt for this creation.

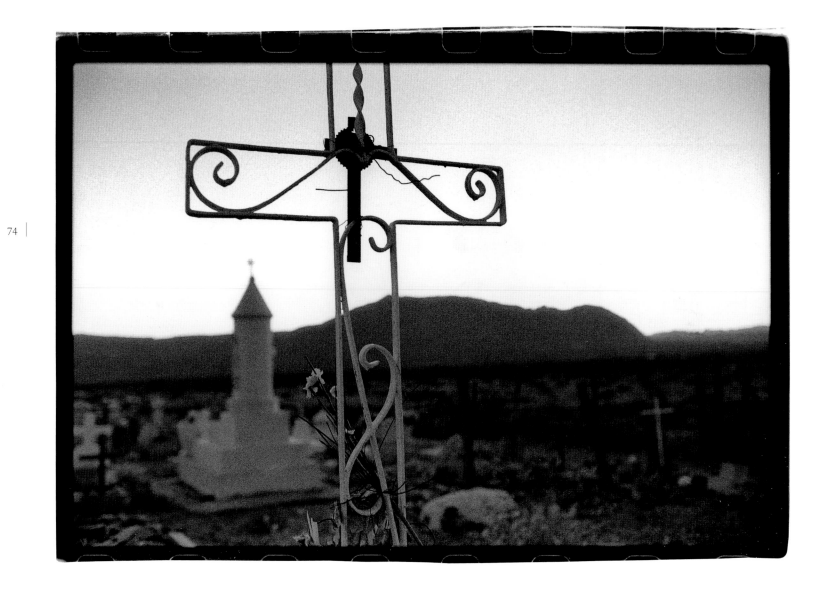

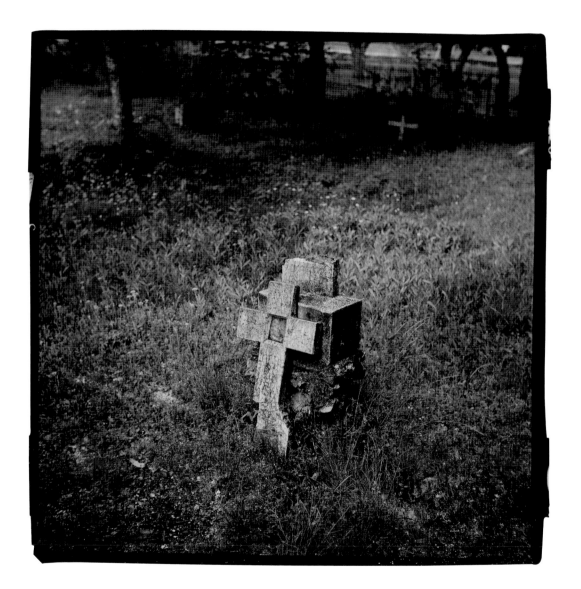

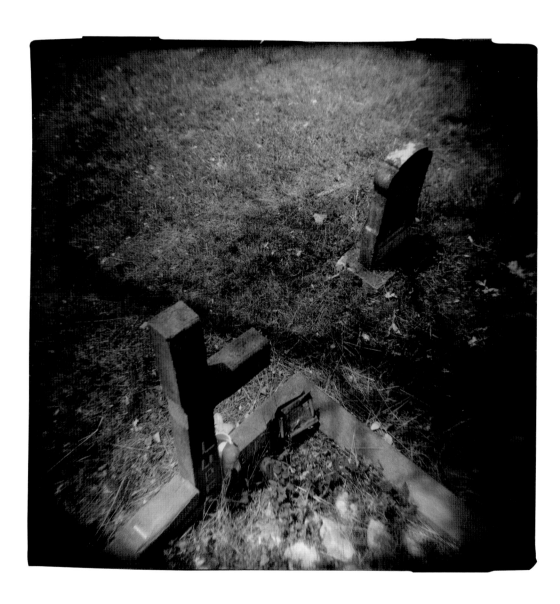

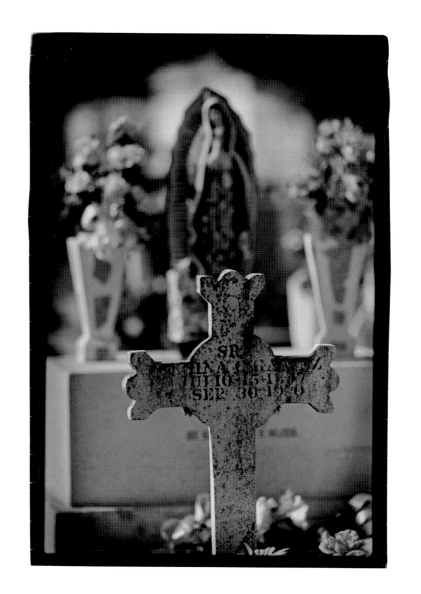

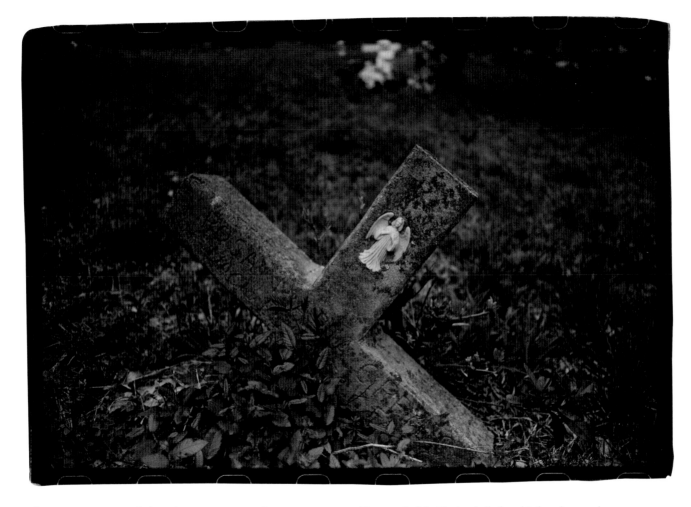

There are numerous symbols in these cemeteries, such as crosses, statues of Jesus and of the Virgin, shells for rebirth and renewal, irises and lilies. And the memories, trinkets, and flowers and toys left by families—all signs of love and faith. But what of the unintended symbols, such as the leaning cross, half-buried, half-lost to sight, nearly lost to memory. The angel is still perfect in its detail, bright against the stone colored with green lichen, while Rosa's name is barely visible in the shallow scratching.

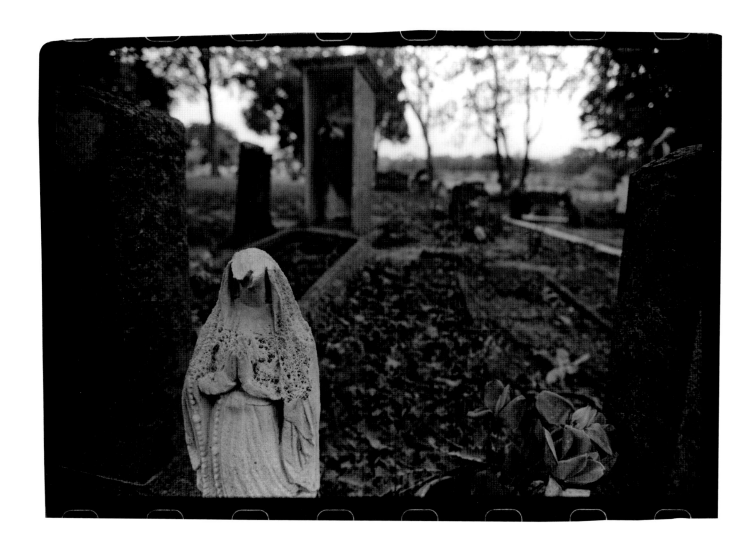

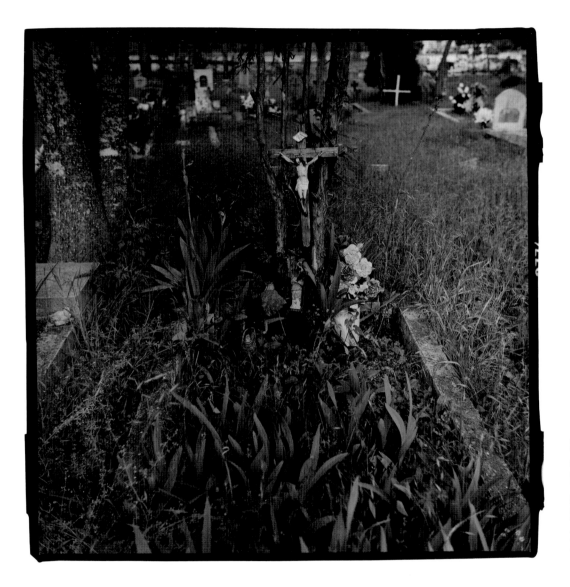

Jesus still hangs with anguish on the cross, surrounded now by irises, not lilies, that have joined the weeds in taking over the grave. The cross is attached to the tree that has grown up where the cross once was placed. His question still lingers: "Father, why has thou forsaken me?"

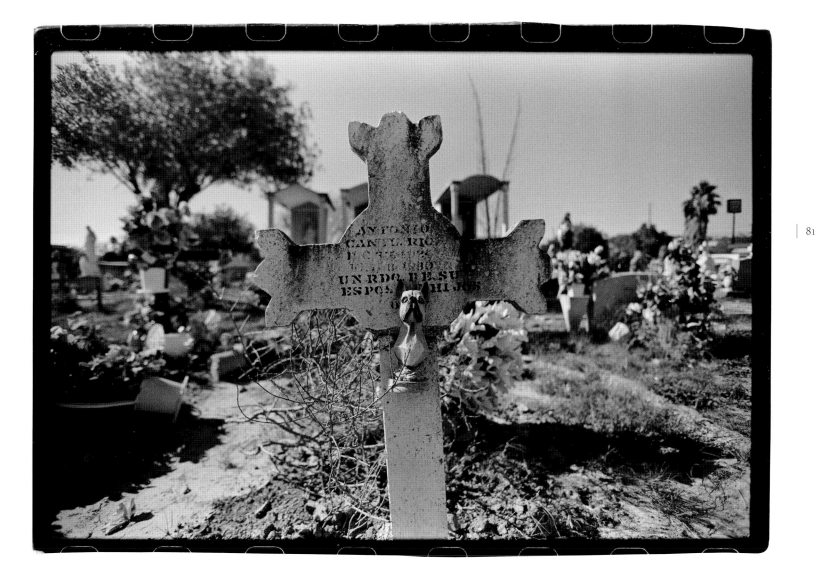

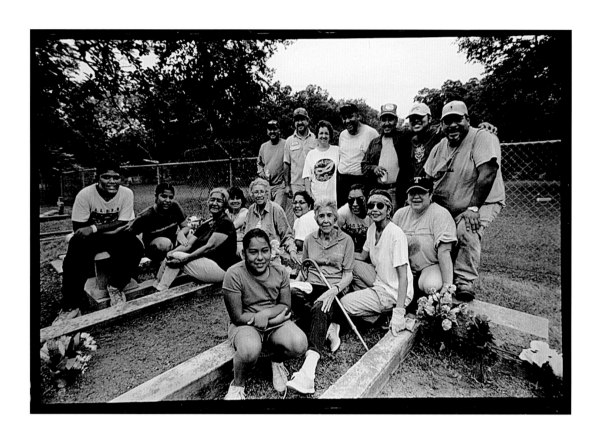

The Family of Sebastian Cardenas

At many Mexican cemeteries, cleaning the grounds is still a family tradition. Families might meet early in spring to cut the grass and clear the debris of winter, or they take turns, coming together once a month to meet their obligation, as at the historical Hornsby Cemetery. At others, cemetery organizations and volunteers take care of the chore, the responsibility, the act of respect.

The Hornsby Cemetery, like many others from the days of plantations and segregation, is divided into three sections: one for the Anglo owners, one for the black slaves or sharecroppers, and one for the Mexican sharecroppers.

On a warm Sunday in May the family of Sebastian Cardenas, one of the original Mexican sharecroppers on the Hornsby planta-tion, met to take their monthly turn at the upkeep of the Rueben Cemetery, the Mexican portion of the Hornsby Cemetery. Daughters and sons, wives and husbands, children and matriarchs of the family gathered to mow, trim, and be together in love and honor. As the younger ones worked, the matriarchs, Rita Cardenas Sanchez, and her sister, Maria Alba "madrecita" Cruz, strolled through the cemetery, talking of recent days and speaking of old memories.

As the work wound down, family members shared one more custom: they spread food—tortillas and beans and fruit—on the tables they had brought and came together for a meal in love and respect for each other.

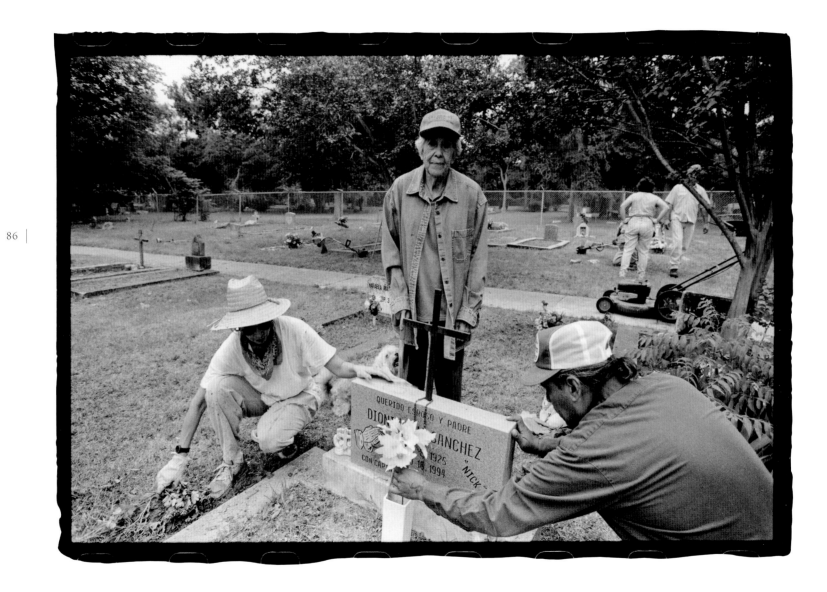

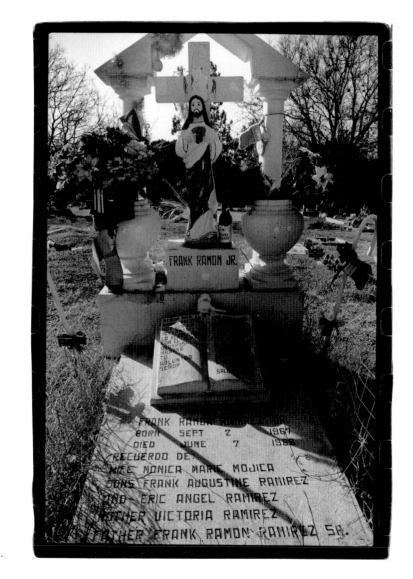

Frank is not alone. Family names in the concrete say so. They remember Frank at Christmas, stockings waiting to be filled, candy canes. Curious, this mix of holiday practices across borders. Jesus is there in the late afternoon sun for Frank, to talk to if he feels like it.

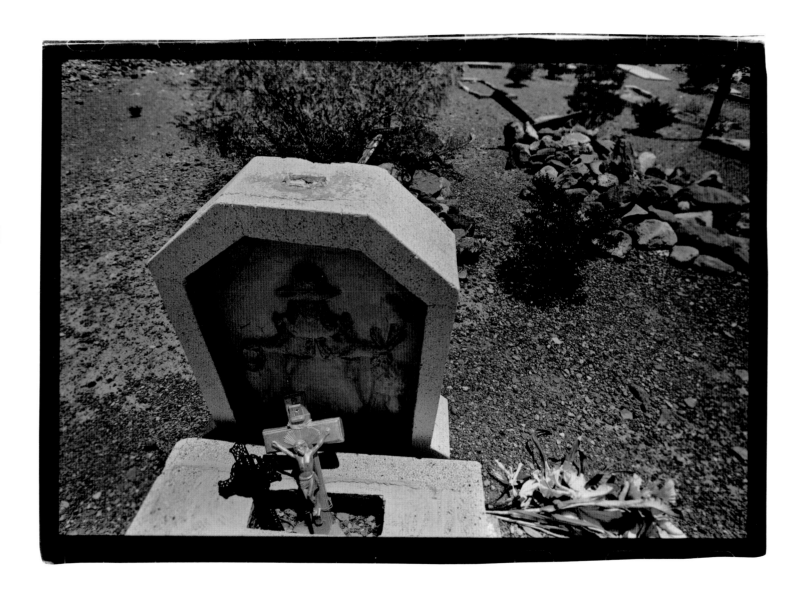

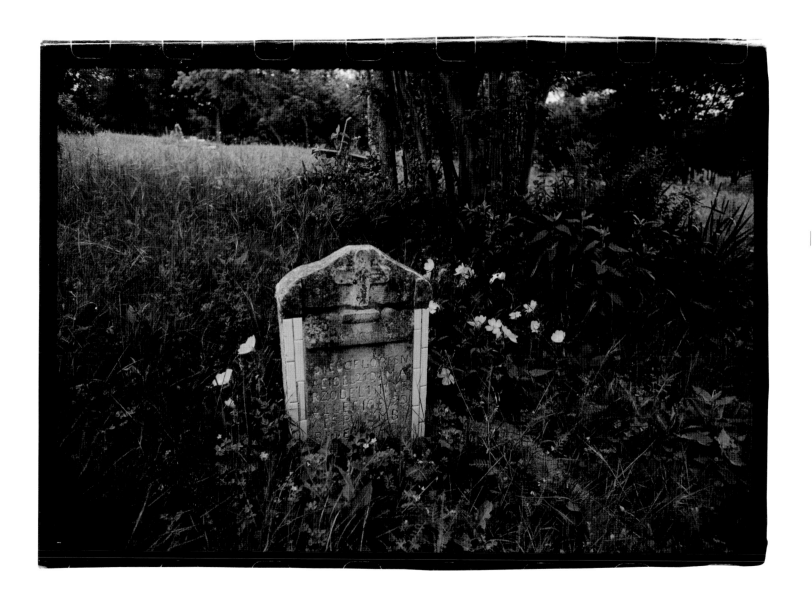

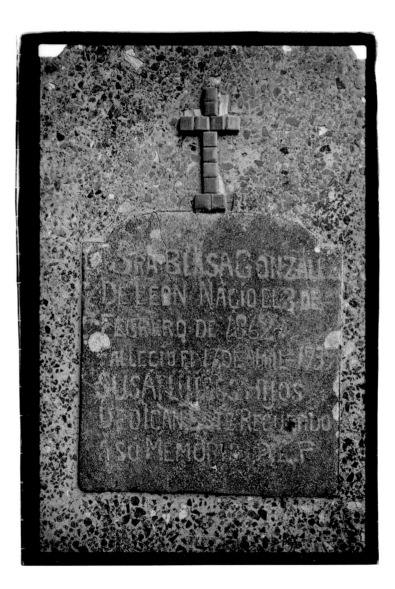

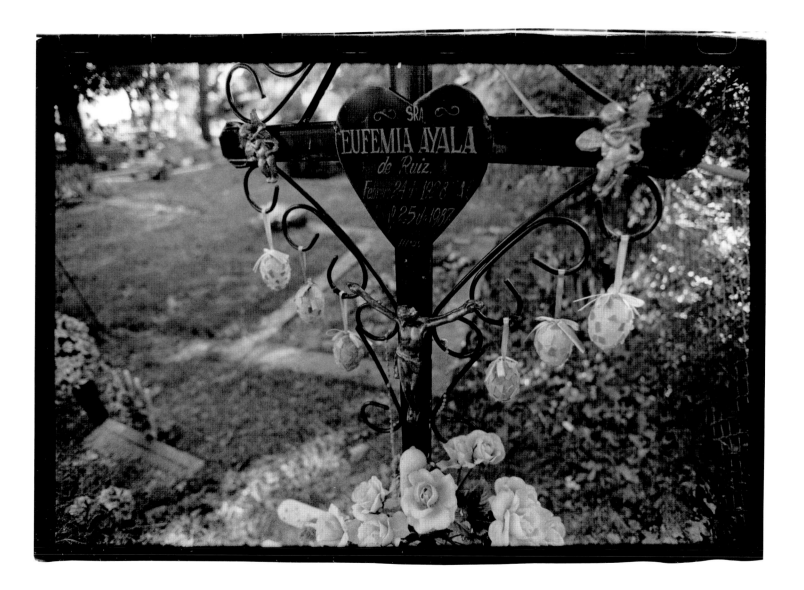

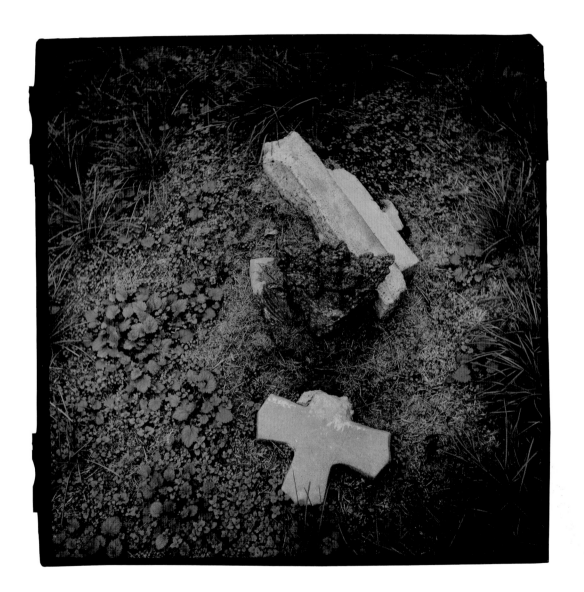

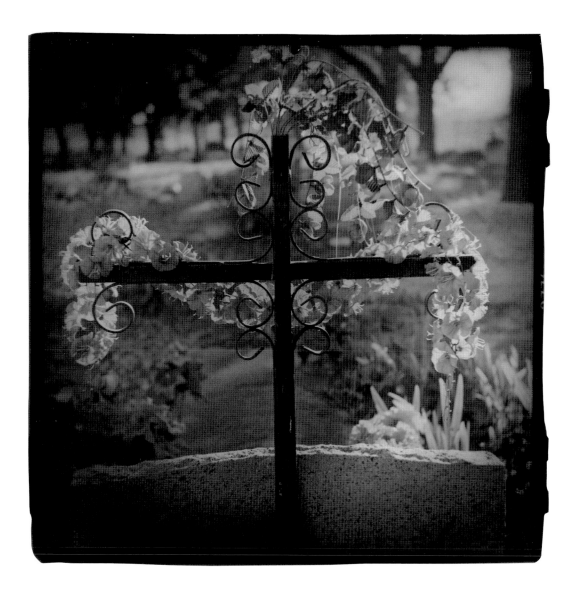

We came here, out in the desert along the Rio Grande, because of a friend's suggestion. Monuments—or, more exactly, constructions—are unique. Walking among them feels as if we are walking through an ancient abandoned village now waiting for someone to tell its tale. The whole area has the feel of a ghost town, or a community gone thin. But the light isn't right for shooting. Clouds are building in the south, across the river in Mexico. That might make for an interesting shot if the storm makes it this far. If not, we can come back early in the morning when the light will be beautiful and warm. We go across the road and up the hill for dinner; the day had been long. We sit outside, watching the clouds as we wait in the cooling air. The clouds are building into a spectacular show of power and lightning. They are approaching faster than anticipated. I look at my son, feeling guilty for what I need to do. He looks at me and says, "Go." I run out of the restaurant and drive back to the cemetery with my gear, spraying rocks everywhere as I race the clouds. Seconds and minutes might make the difference between a great photograph and just another tourist's snapshot. The drama of the building storm is magnificent, nature at its most powerful. I keep taking pictures until the rain starts and the light fades. Our waitress and other diners helped my son move our meal inside. She had asked him, "Does your dad do this often?" "Yes," he replied.

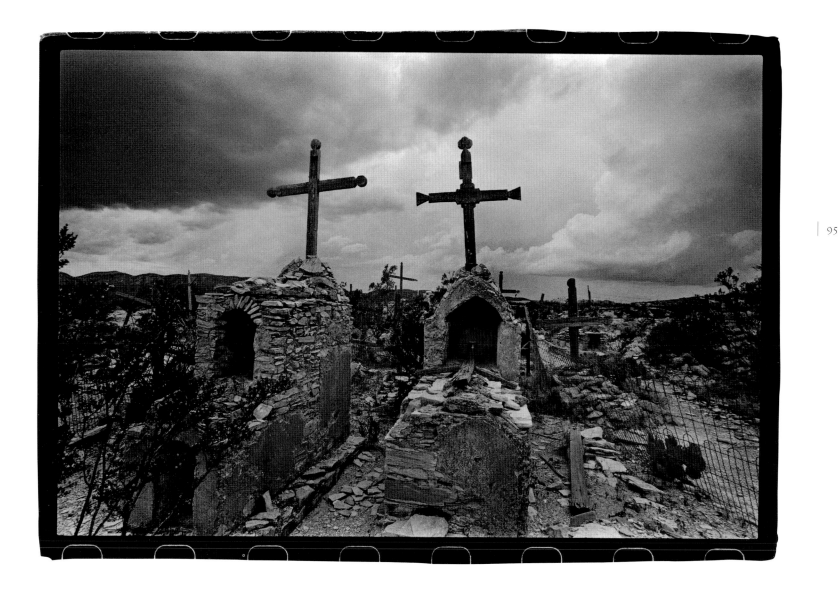

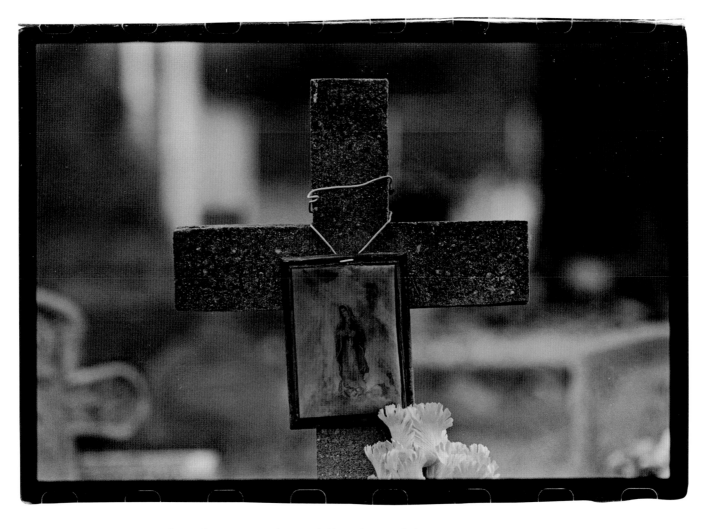

How soft she is, resting against the rough concrete. A nail was probably used to scratch the name, barely legible then and now. The wire is put on roughly, like the concrete, making do in a time of little money. No perfect twist, no final trimming and shaping. Where was it used before?

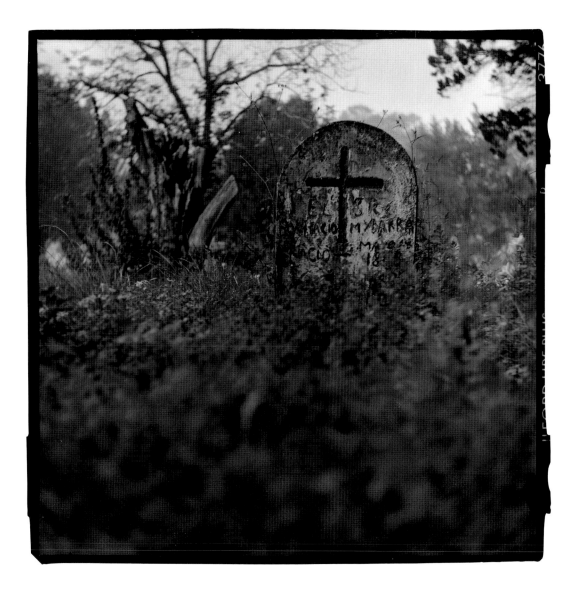

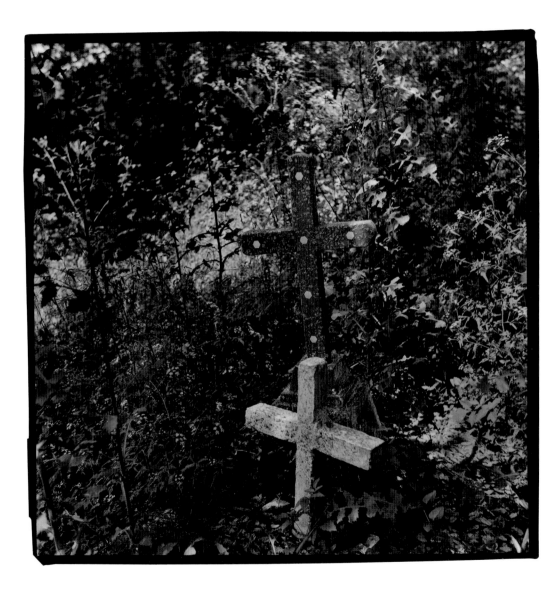

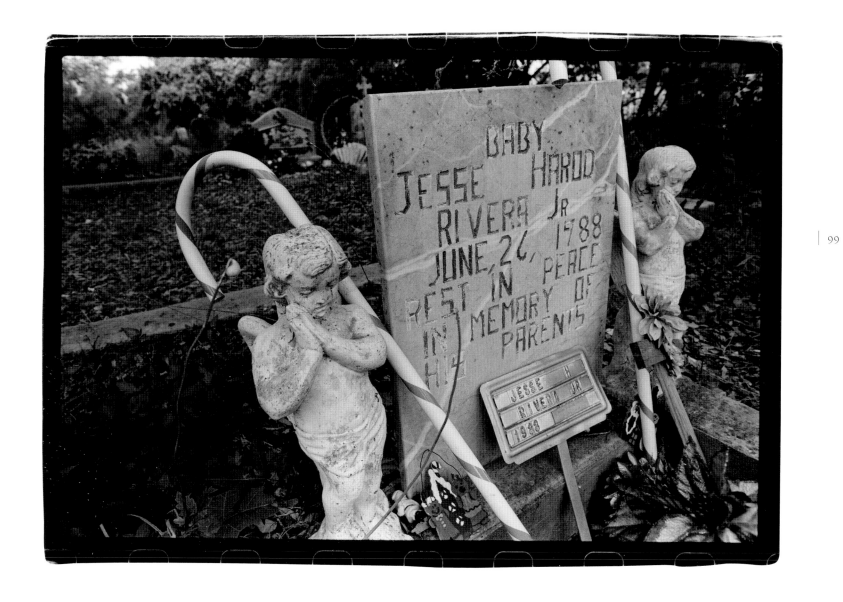

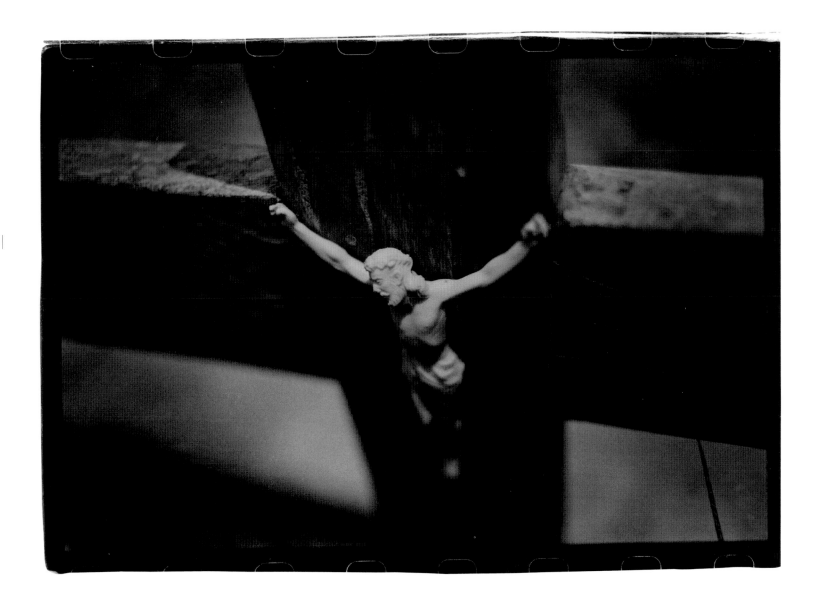

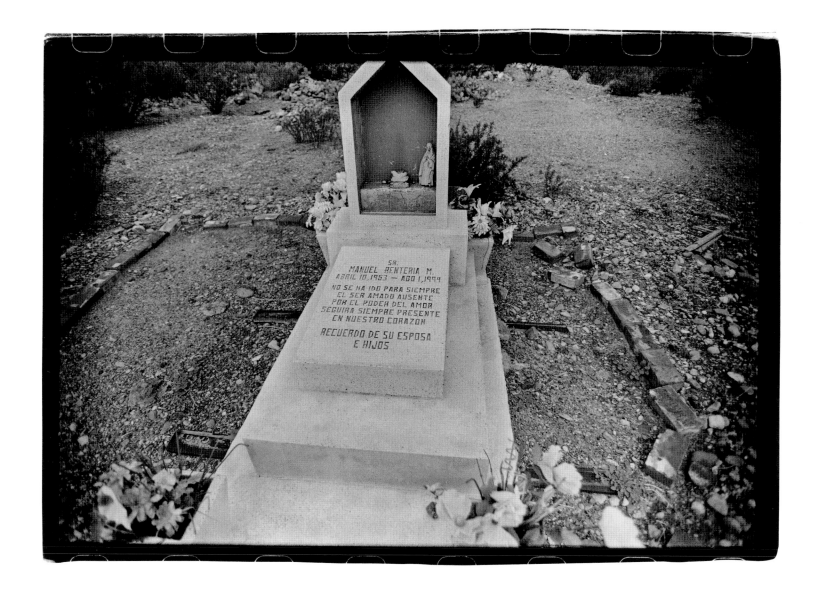

There is nothing in the concrete headstone, no picture, no statue, other than words made of wire. So perfectly formed, bent and pressed into the concrete while it was soft, then painted a light, sky blue. The paint is flaking off now, so many years later, but the letters are still perfect. That kind of love and respect endures a long time.

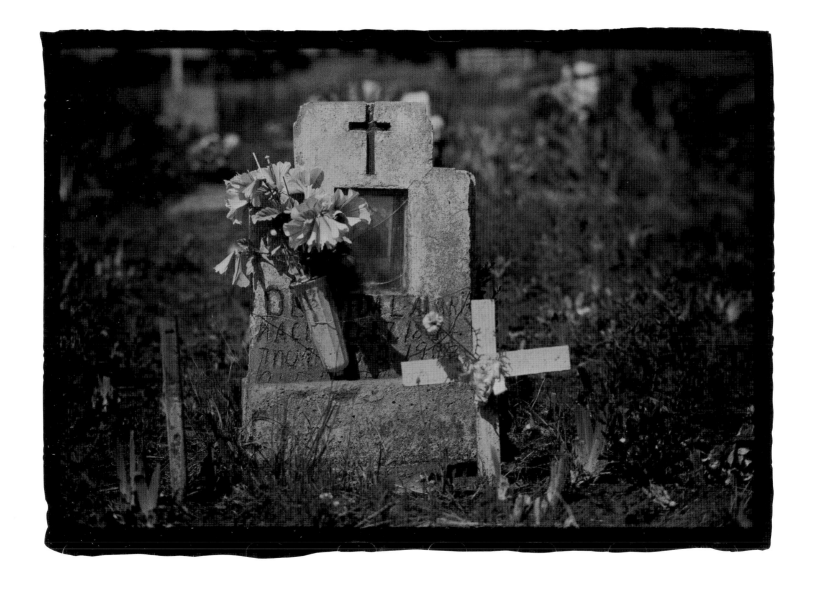

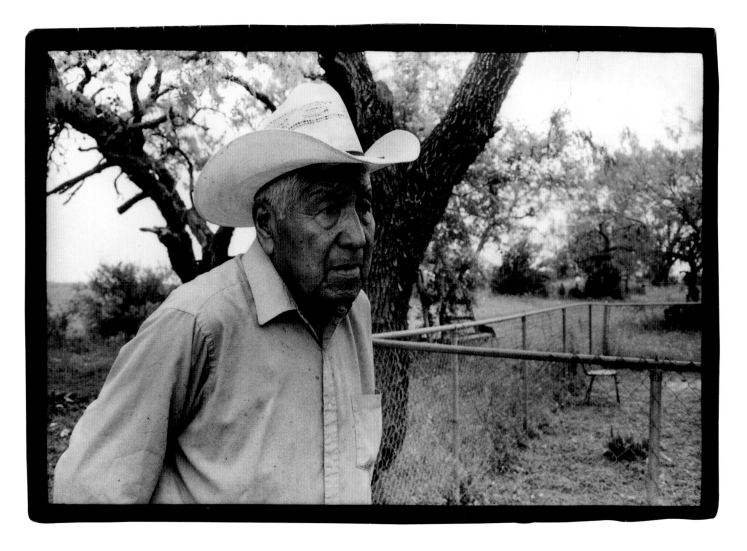

He is there to clean and mow. He had gotten a ride from a neighbor in the town where he lived because he can no longer drive. There is no one left in the family to take this responsibility so he has to do it.

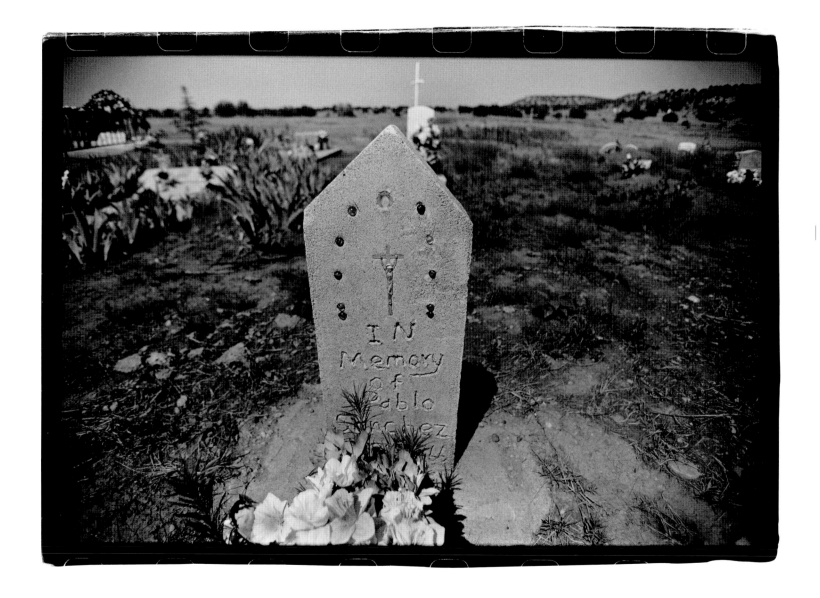

This small block of concrete, scored while still wet, shows lines like notebook paper to make sure the lettering is as straight as possible. It has the dates and wishes: *Recuerdo a su querida*. The depth of each letter or number is the same, the angles of the letters nearly so. The concrete is filled with letters. Just letters and numbers, no decoration, no picture, no small figure of the Virgin, no statue of Jesus. How slowly the creator must have worked. How meticulous he tried to be.

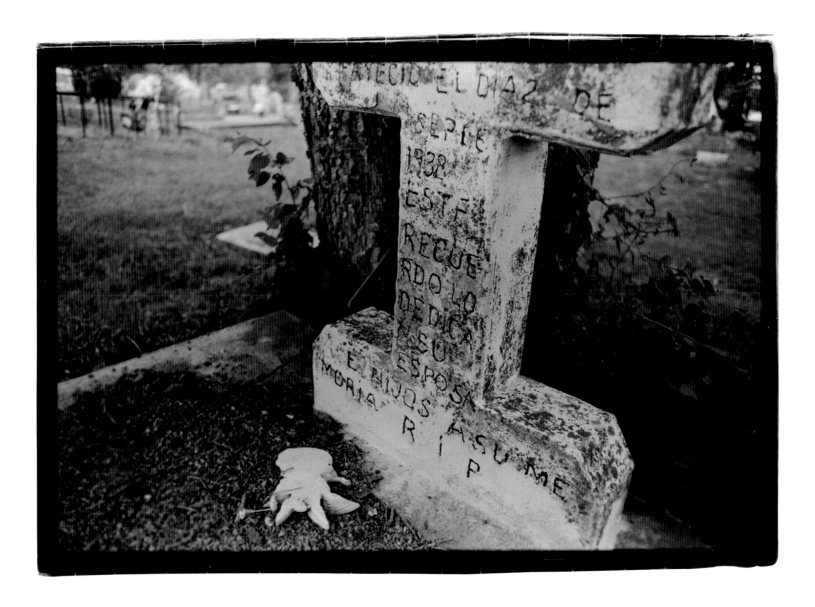

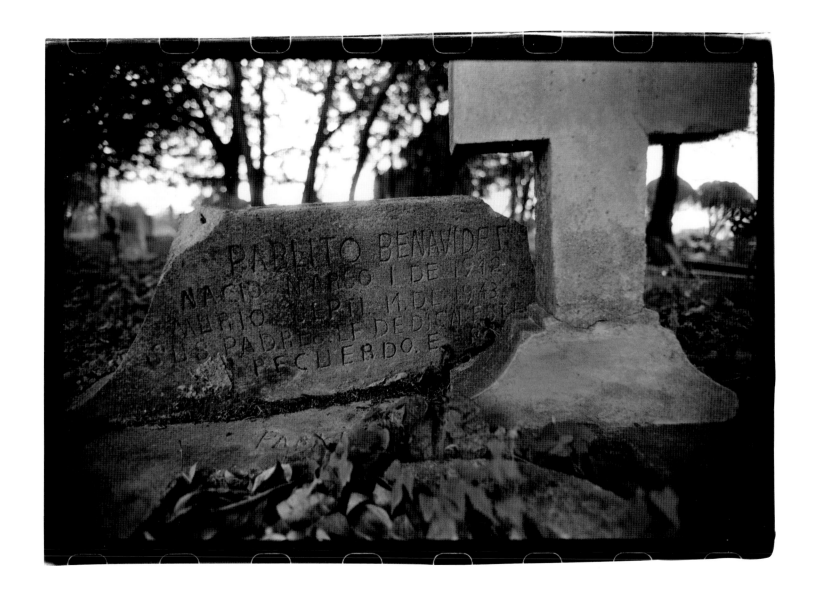

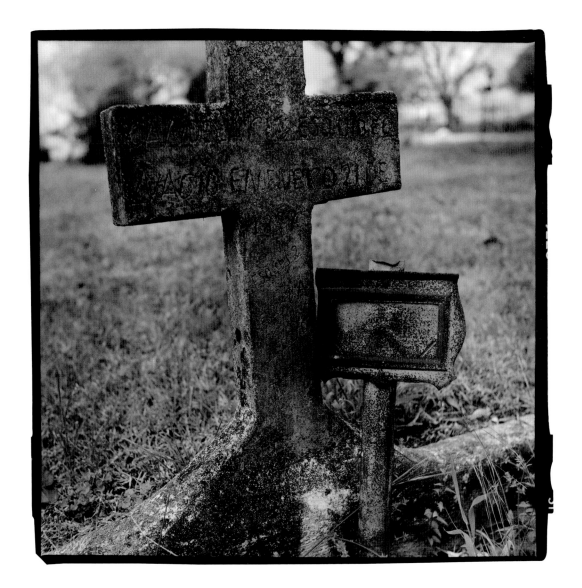

This cemetery, like most, is overgrown. The crosses are like ghosts.

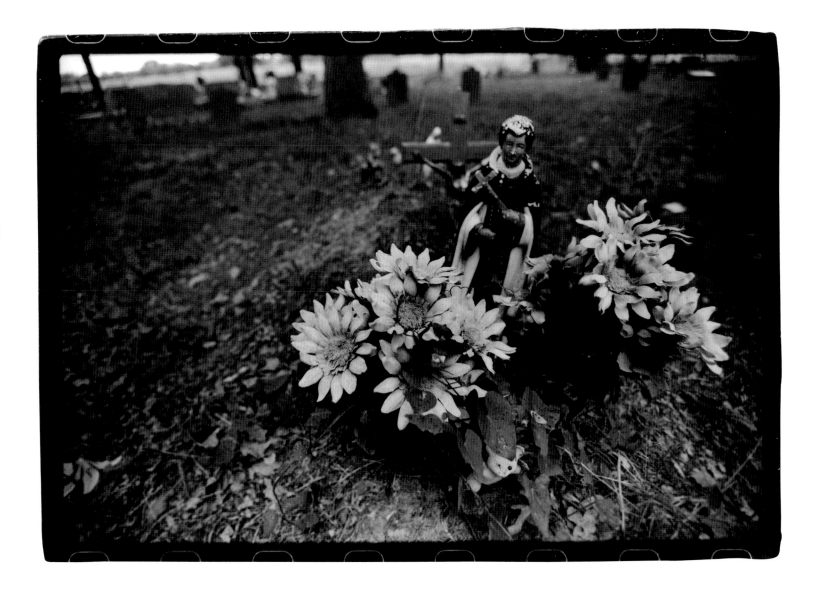

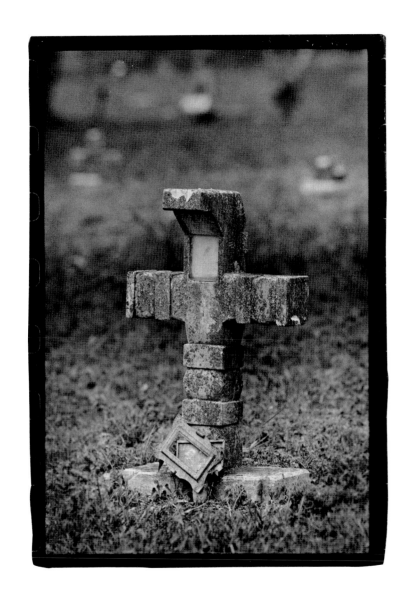

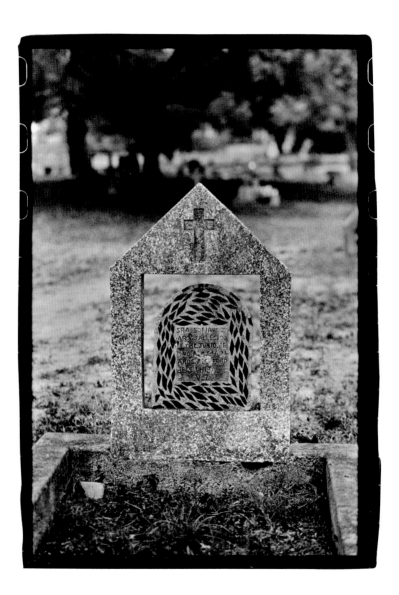

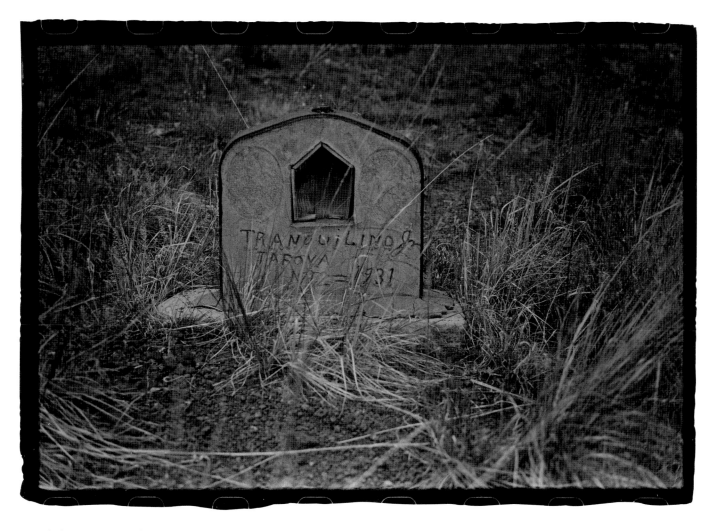

Simple, love is. Respect. The maker had used the frame from an old car radiator, a Model A or who knows what, as the form for the concrete. Two ceramic medallions, now gone, and a nicho made of scrap wood to hold a cross or a statue of Jesus or the Virgin. An elegant solution in dry times, dry as this land. All gone now, like Tranquilo.

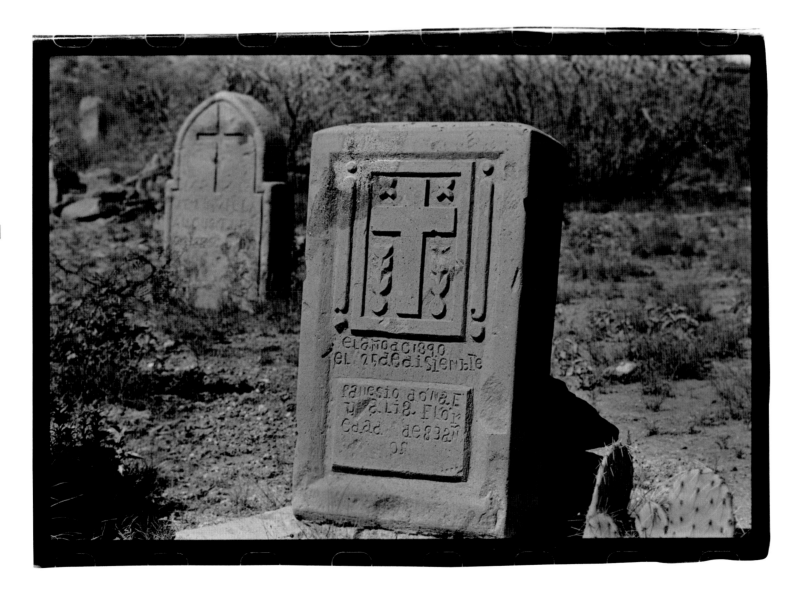

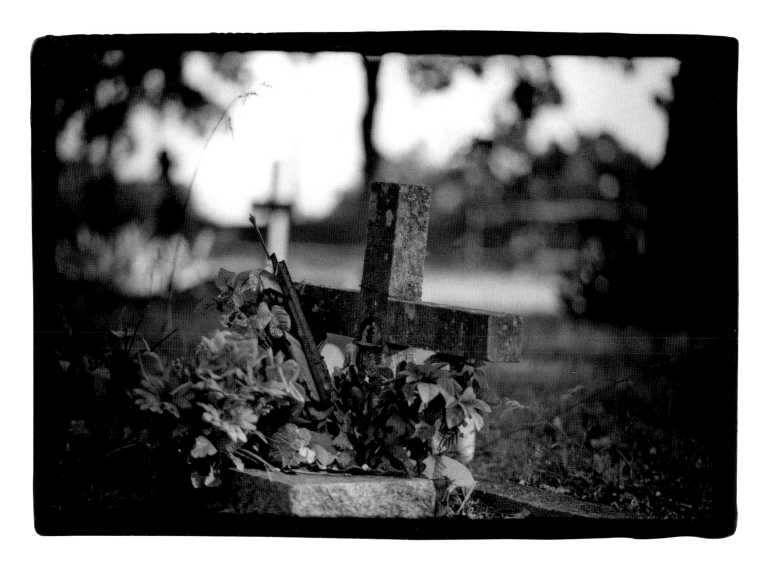

This cross bears a blessing, as it should. Is it Jesus, or is it the father and the prodigal son? No matter.

Luz had been buried with both the metal marker from the funeral
home and a handmade wooden cross. His name and the date
of his death are painted on the cross with a small brush in simple
black paint: 12-3-2007. Fragments of porcelain lay to one side of
the cross. A porcelain figure sits in the dirt and leaves are gathered
on the other side. The figure has nothing to do with the religion
of Luz; it has nothing to do with religion at all. Perhaps someone
thought Luz deserved something pretty to decorate his grave.
There is nothing more, except a few irises and the leaves collected
by the wind. I wonder how old Luz was when he died.

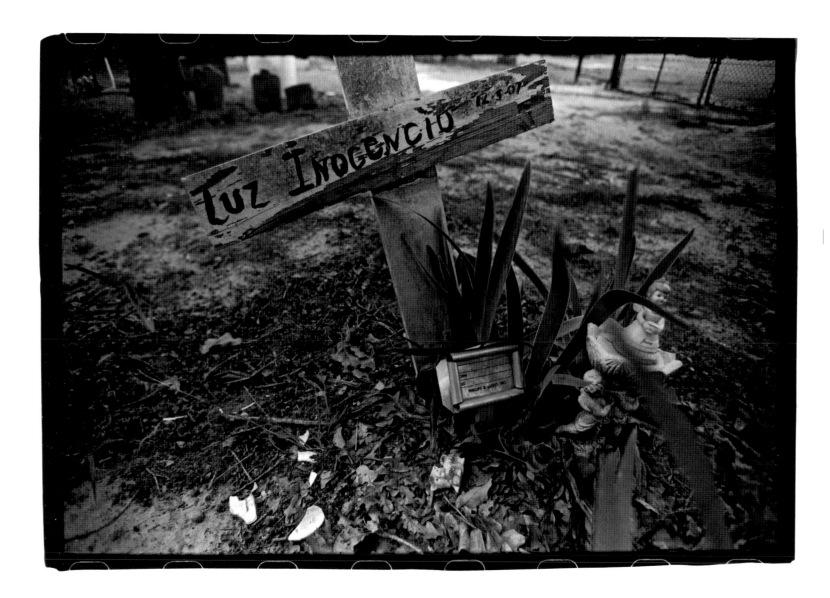

120

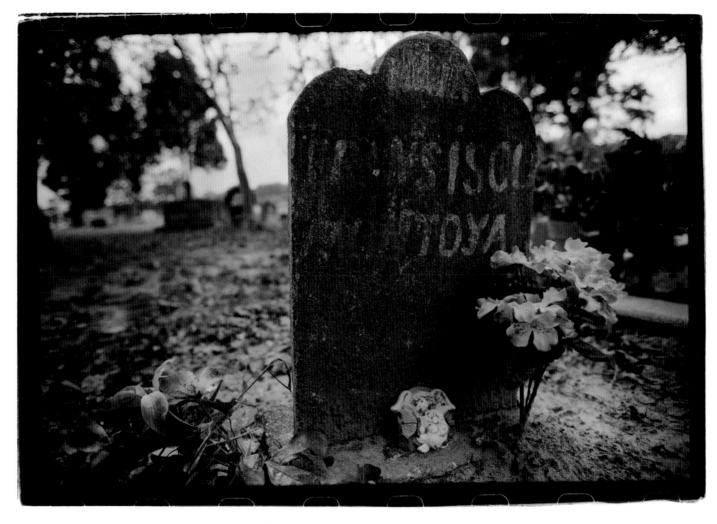

Little is known about Francisco in terms of months and dates. Someone cared about him, though, and made sure he was buried in the cemetery. Then someone made him a headstone and painted his name on it. But nothing fancy. Someone left a small porcelain figure and some flowers—not real flowers, but at least they lasted, like the simple headstone, showing someone cared.

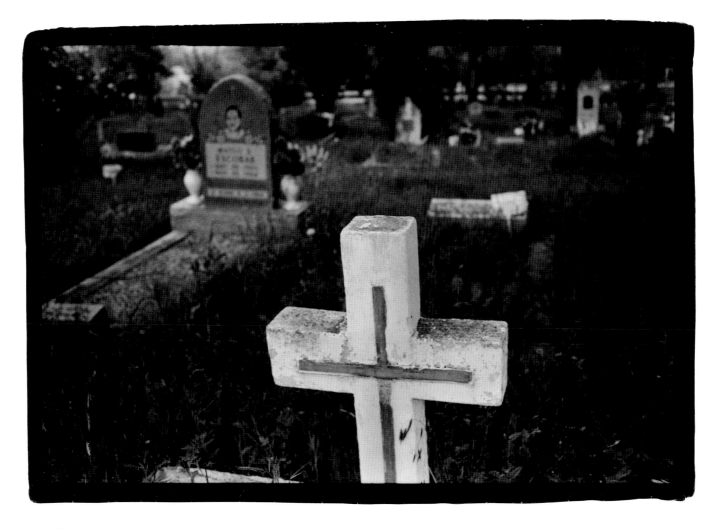

A visual contradiction is starting to emerge. The older, handmade tombstones and mausoleums are starting to be accompanied by polished granite with engravings and pictures. In fact, the new often replaces the old, now having been removed by families. Families want to show their love and respect, it's true, but the new seem to be just one more manufactured memory, not a giving of the heart through the effort of the maker.

It is almost hidden in the tall grass and weeds. A cross and two letters, perhaps the initials of the dead, scratched into what at first appears to be just a stone in the field. What tool had been used to do this good work, here, on a hilltop above the one store and bar in the mountains and ranchland of southern Colorado, almost overlooked in the tall grass and weeds?

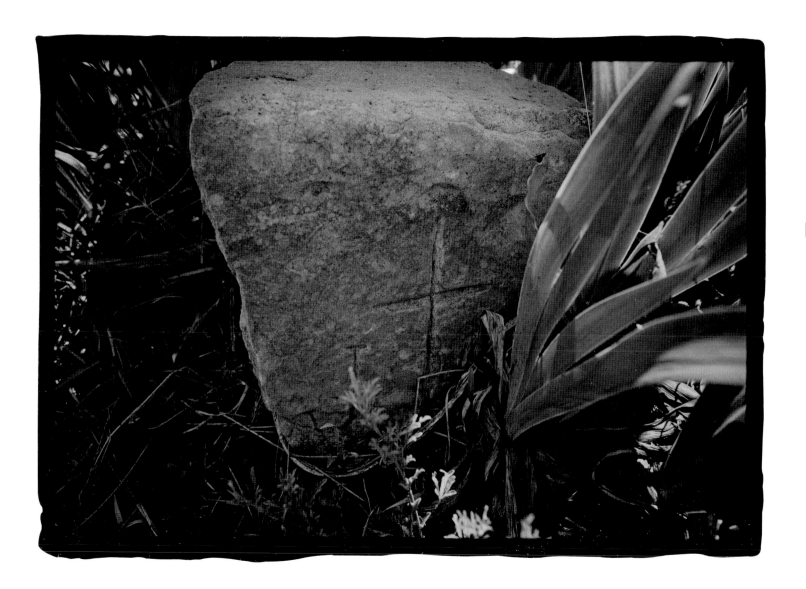

123

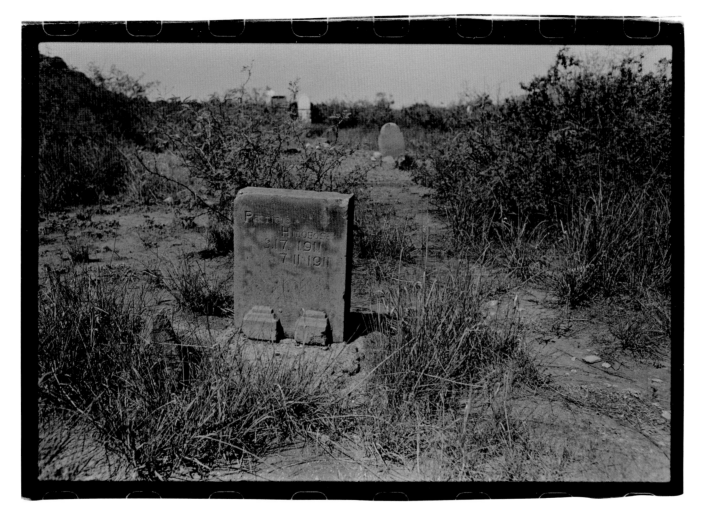

The scene is monochromatic, totally absent of other colors, nothing to add drama to the photograph. No color, no light, no darkness, no rhythm. Just sand, dry grasses, and prickly shrubs. Sandstone markers are scattered randomly throughout the cemetery, metaphors about the lives of the people. The day is getting hotter. It will be unbearable soon.

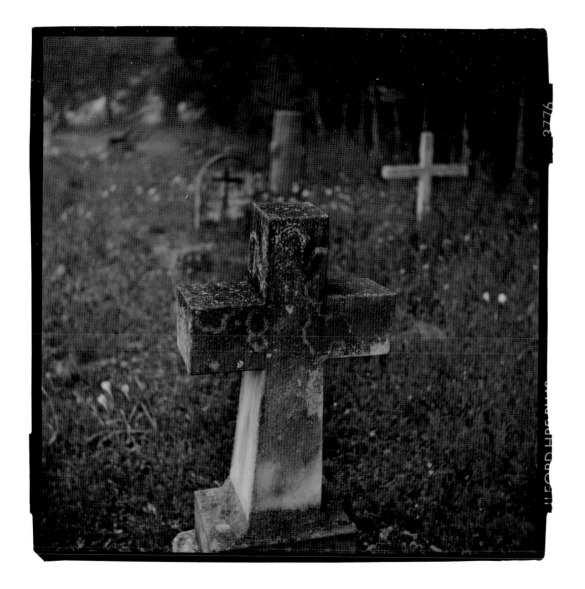

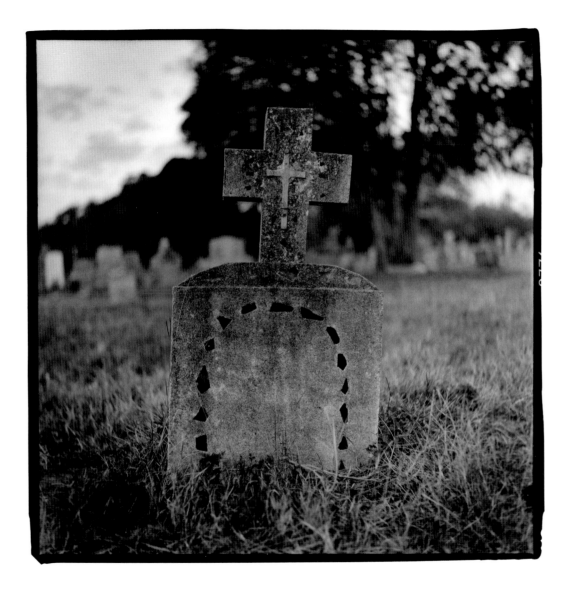

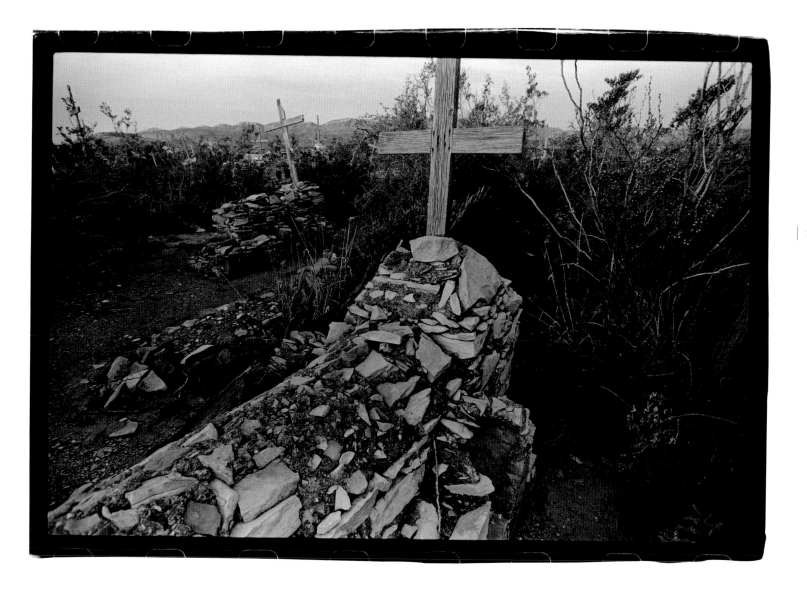

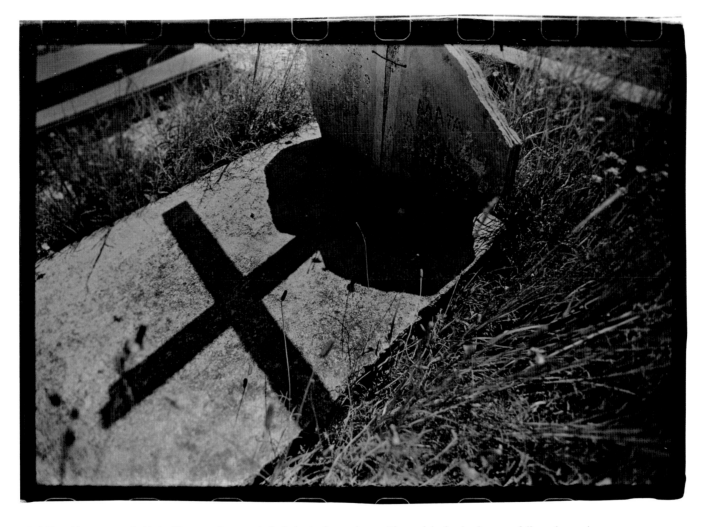

A drift and hammer probably had been used to punch the holes in the sandstone. The work had to be done carefully or the sandstone would chip and shatter; the layers might fracture and break apart. In fact, the stone looks as though it has fractured around many of the holes over the years. Painstaking work to punch out a name and dates into rock. The cross, wired to the rock and made of wood, is plain.

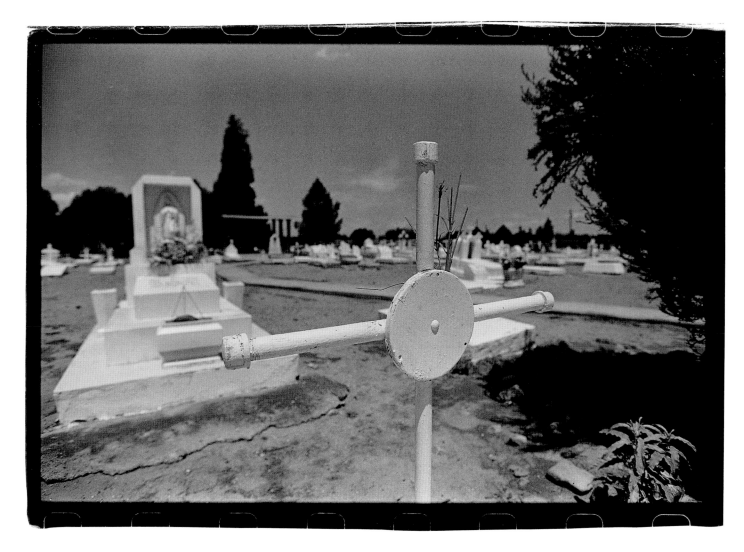

This is all that is left to mark a life: pieces of pipe with a wooden disc on them, painted white like all the other graves, reflecting the bright sun in the heat of midday, surrounded by baking sand.

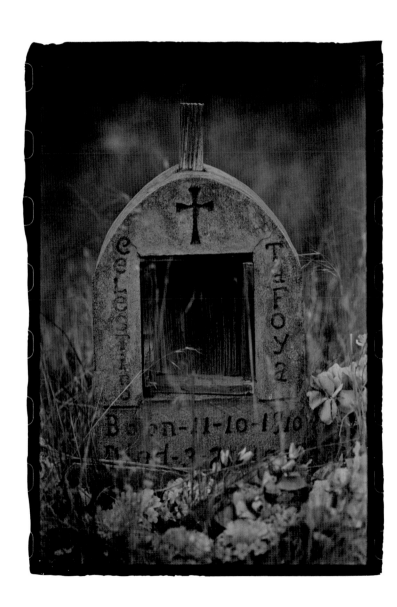

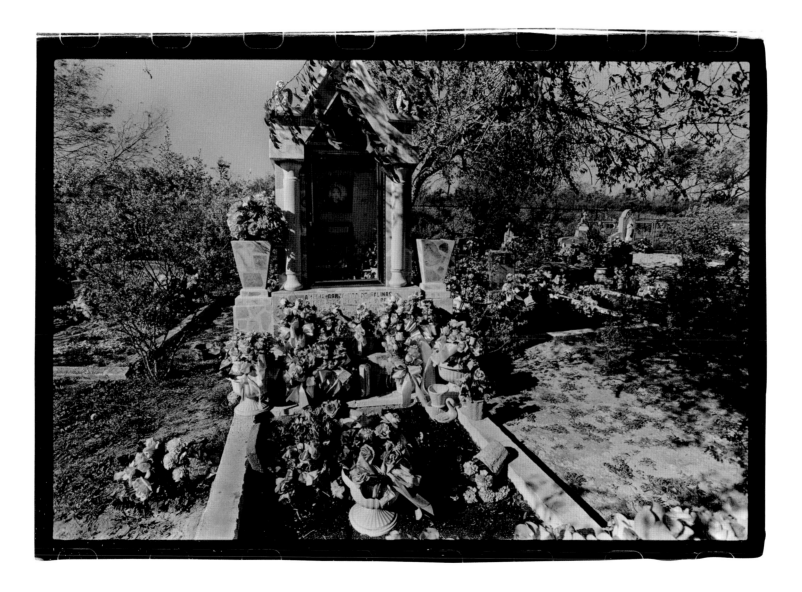

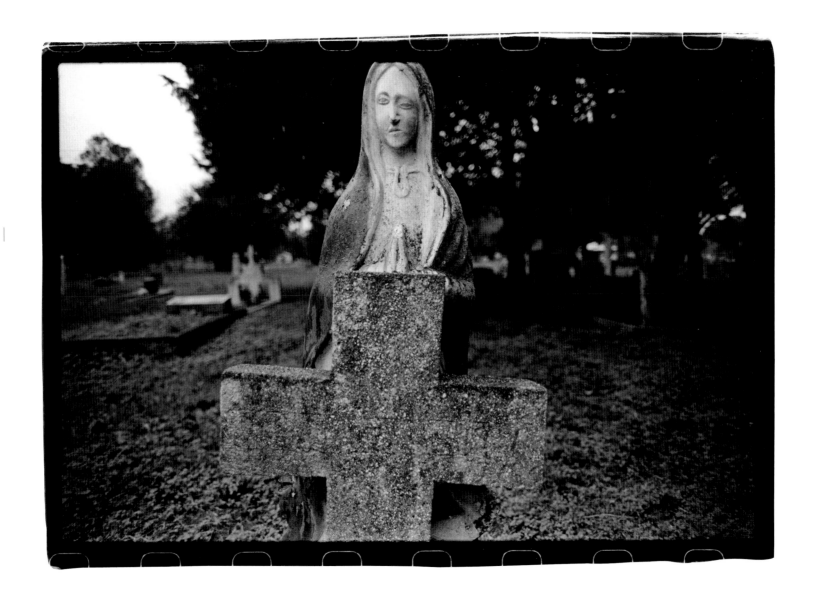

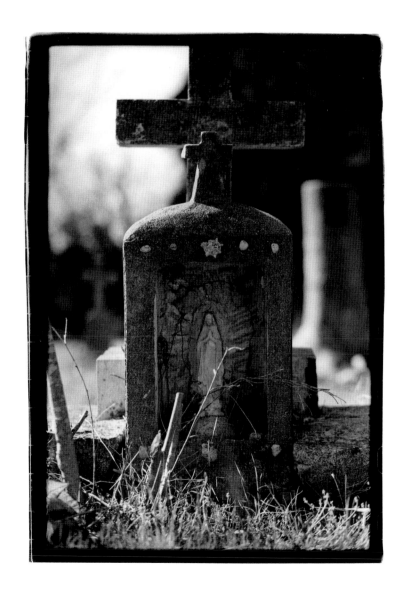

The cemetery isn't organized in any way. There are no neat rows, measured and centered. Wherever someone wanted to bury a loved one, they did. All types of headstones and decorations and fencing are seen, from old to ornate, filling the grounds. Julian Calderon's handmade concrete cross and edging with inlaid tile catches my eye. His name is perfectly set with a photo or emblem of some sort centered above the metal type. Vases etched with "We Love You Dad" rest at each corner: a contradiction, only a momentary thought. There are no flowers in them, new or plastic. Jesus, standing tall above these details, presides over the trophies and small ceramic statues. All of this, plus the grass and weeds had not been trimmed or cleared away by anyone for at least a season, maybe longer.

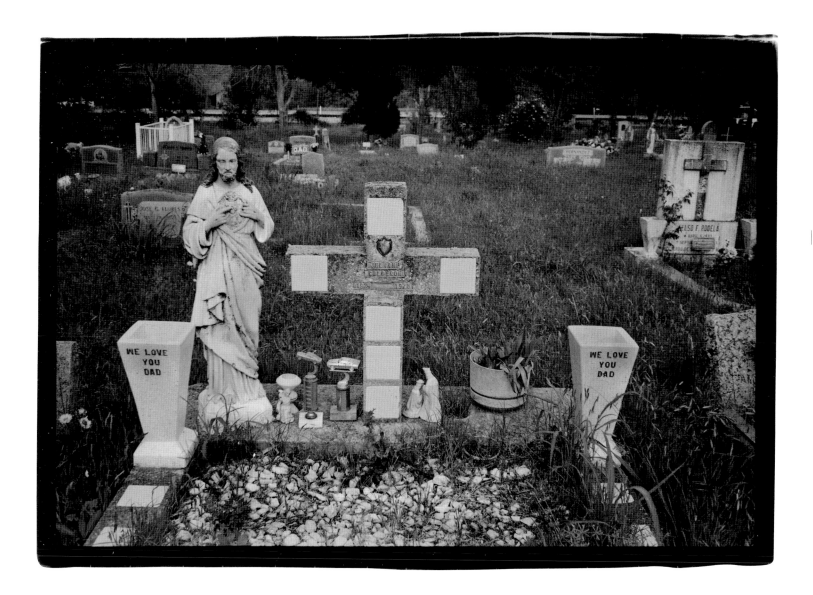

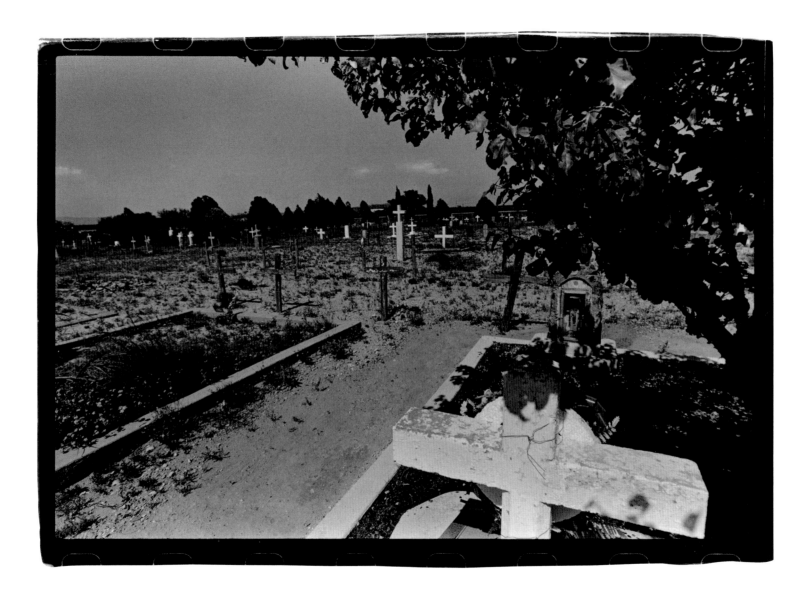

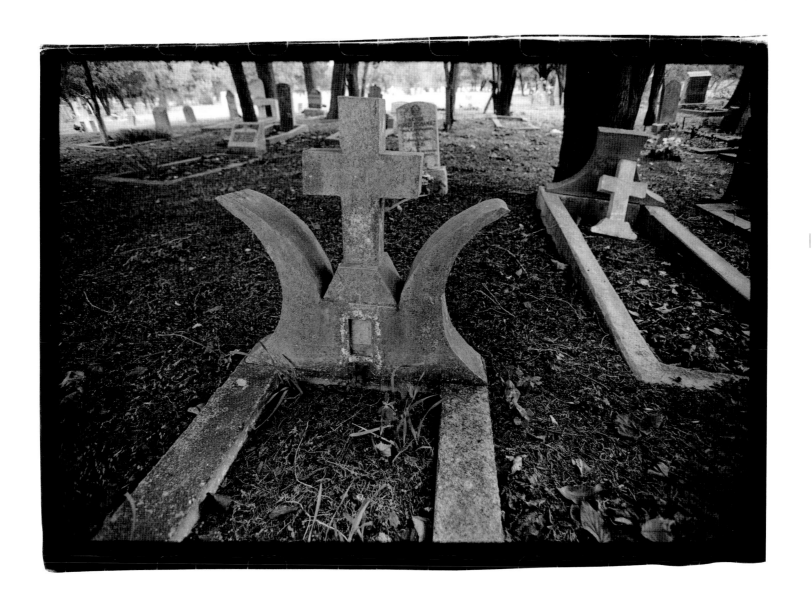

White crosses, almost exclusively wooden, mark most of the graves in the dry land of this New Mexican cemetery. There are a few stone or granite headstones but not many, and mostly on the newer graves. Why so many wooden crosses here? The paint is faded, worn away on most of them. What happened to the families?

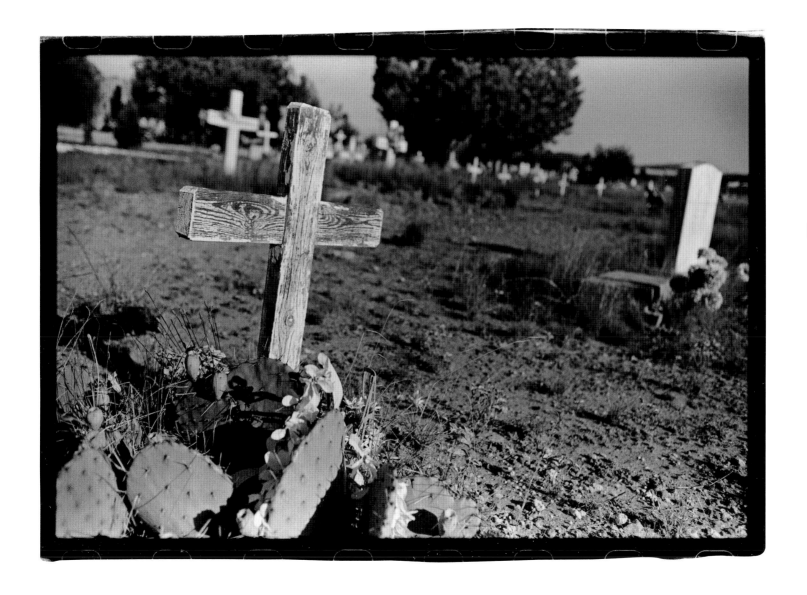

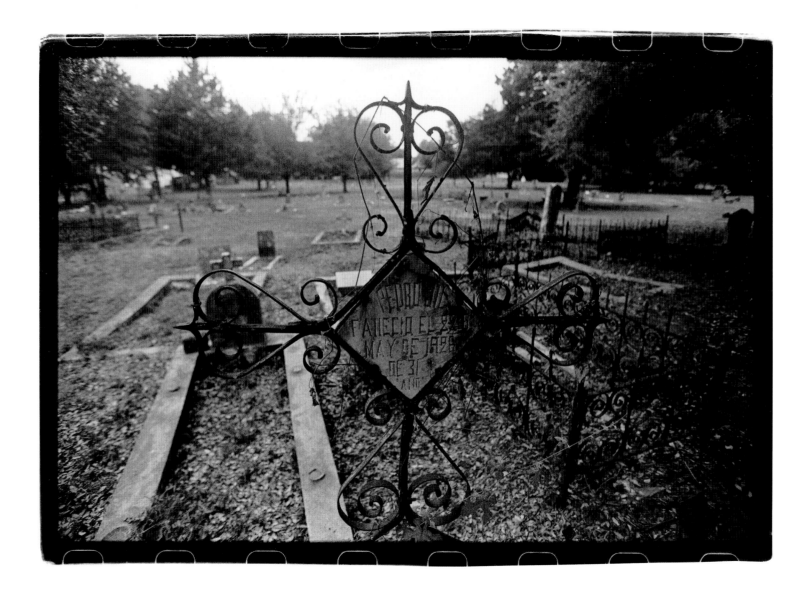

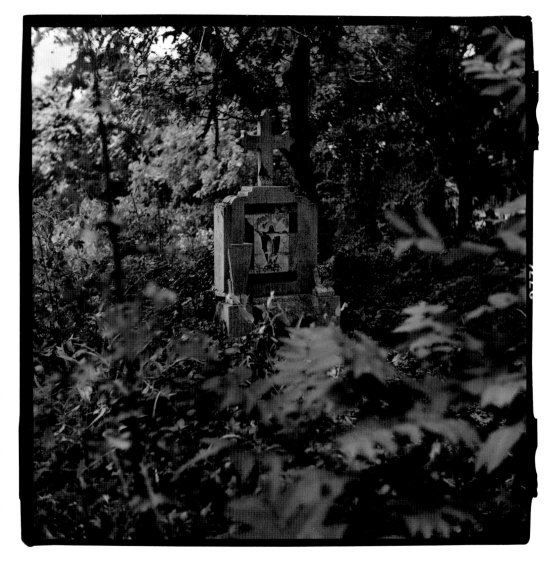

The grave stands alone, deep at the back of the cemetery. Getting to it takes careful movement through limbs, brush, and brambles, to reach the small clearing. It seems out of place, deep in the growth, far from the road. Why is it back here, this large, this carefully built memory? Vases like sentries stand cracked by age and falling limbs, long absent of flowers, the whole construction with the once and still beautiful tile of Jesus' arms outstretched, beckoning.

The new granite stands out in the desert environment, the white against the brown. They are replacements for rocks and 2x4 crosses. The problem is, the rocks will last longer in the dry desert heat and continuous sun while the manmade granite will slowly crumble. Only a few families come to visit anymore.

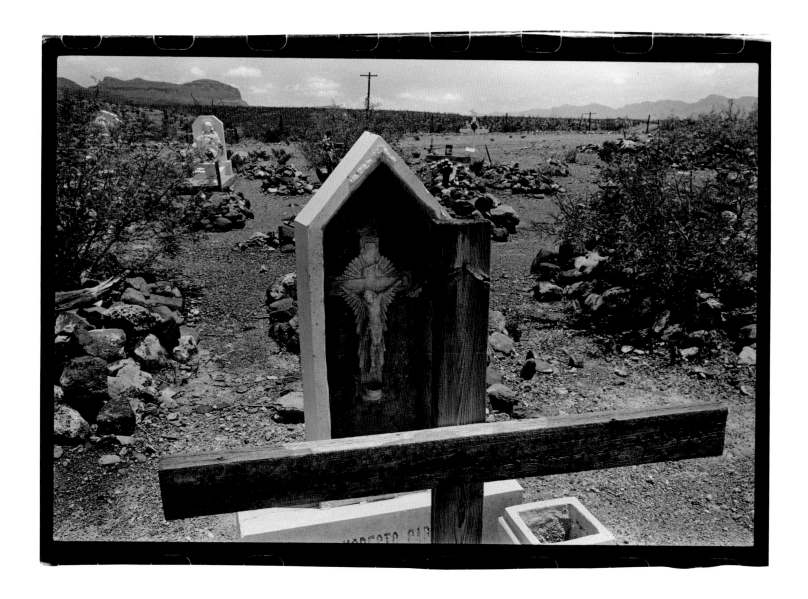

I meet Catarino "Cat" Montelongo Jr. at the cemetery. He has come to visit family. Cat had grown up in the small town but moved away for work. He still comes back from time to time to visit and keep the family's plot clean for the deceased.

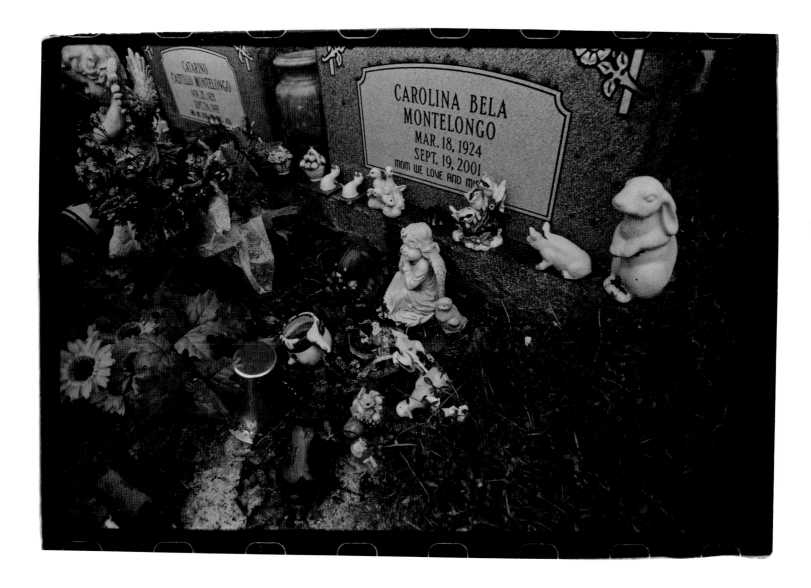

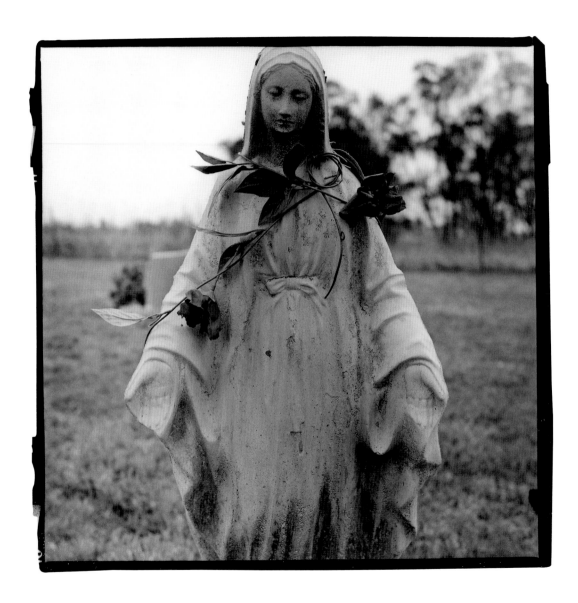

An Interview with Bruce Jordan

Milligan: In your artist's statement you describe the urge to document a vanishing art form, but your style of photography makes significant use of mood-enhancing techniques, such as emphasizing the interplay of light and shadow, leaving intact vegetation that obscures the art and/or inscriptions, a limited amount of soft focus, etc. Can you define exactly what you feel that you are "documenting" with this type of photography?

Jordan: I work with the three things you point out: the object, the mood, and the setting. Those are my paints and all three are important to me. When I use the term "document," I have paired it with "artistic" in this project to bring voice to the style of the images. Had I only used traditional documentary photography, I feel the images would not invoke the type of emotions I feel are present in the work of these craftsmen. Therefore, I am not just documenting an object but emotions, place, and a sense of time.

Milligan: That begs the question of whether or not it is the work of these craftsmen, or the combination of their work and the context in which their work exists, both physical and cultural, that makes it worth documenting.

Jordan: When we think of the past, our emotions travel to a different place. We may feel joy in the memory or perhaps feel melancholy and longing for a return to the time of that memory. Much of the mood that is or isn't apparent in the photographs is based on both the time of day, and what that afforded me to work with, and the location. Being true to the location is also very important. I hope the viewer feels something that I felt during this process. You have noticed these things, so I hope that means I succeeded in my goal. A big part of this project is the desire to connect with another culture. A theme in much of my work is about the passing of a way of life, a homogenization of one culture with the dominant culture. This process says a lot about what is going on around the world as cultures mimic other cultures, speed becomes more important than form, getting more for less—even at the cost of quality, creativity, and

personality. We are rapidly losing the personal, even as people talk about "individuality." How can there be individuality when we shop at big-box stores that run this country? I am also trying to document a time before this loss.

Milligan: In the larger cemeteries in San Antonio, Laredo, and other urban centers in south Texas, the older monuments are often fairly tall. Your photographs tend to focus on smaller monuments, often requiring ground-level camera placement. Did you find that the smaller monuments tended to be the handcrafted ones?

Jordan: Yes. The larger pieces had to be professional, almost industrial, constructions. Smaller ones could be created in a backyard or garage or small shop without the help of equipment necessary for moving large pieces. Even some of the smaller pieces still had significant size on occasion.

Milligan: Carlos Cortez maintains an active workshop in San Antonio, where he carries on the tradition of hand-sculpted concrete. Carlos is the grandson of George Cortez, who was a student of Dionisio Rodriguez, the Mexico City artist who invented the art form of sculpted and colored concrete (still a family secret, by the way); and who was responsible for the concrete sculptures in Brackenridge Park, at the bus stop in Alamo Heights; and of numerous other recognizable works throughout San Antonio. Have you sought out any of the craftsmen who carry on this art form? What did you learn from them, and how did that knowledge affect your photography?

Jordan: I have heard that there are still one or two people creating these monuments, but have not tracked them down. That is another book. I saw some new pieces in Taos, but they were very simple and usually made of wood. I saw a few other pieces in a small cemetery not far from Taos that incorporated stainless steel. No more iron but flashy stainless steel; still a creative answer, but not in keeping with the tradition of welders and wrought iron. I think this says something similar to what the switch to granite says: it is slick and smooth. Otherwise, I have not seen any new creations in my travels. This is one of the points of this project. Fathers are rarely passing on their craft and their love of craft and community. We have given our time to other things, like television, instead of community. Many cemeteries are not allowing hand-built pieces these days. As monuments and headstones age and crumble, maintenance of the grounds becomes more difficult. Expediency. This is sad to me, that maintenance is more important than custom. Today everything has to always look new and perfect. Please, let's not show our age. That point definitely speaks to our current society.

Milligan: In visiting numerous cemeteries, did you develop an eye for the work of particular craftsmen? Did you find yourself looking for one artist's work over that of others? Did this lead you to create a speculative history of that artist?

Jordan: This is a good observation. I saw styles that were particular to a geographical location. That says those artists were local. There are subtle variations of a style or slight copies of a style,

148

Milligan

but I have not seen an exact type of creation outside the original cemetery. Something interesting is that I recently saw a copy of one style in the yard at an Anglo monuments works business reproduced in granite. There are definitely some pieces that are more elaborate or detailed, but overall I was in awe of the act of creativity. To have so very little to work with yet be able to come up with different designs and interpretations on a theme is what makes all of these pieces special, whether simple or elaborate. An example of this creative problem solving came when I looked closely at one image during printing. While taking the image I was looking at the overall, not the specific details. Upon examination, the maker had used a file as rebar to strengthen the concrete of the horizontal arm of a cross. Fortunately for me it didn't work too well over time or I would not have had the joy of seeing this. And to give up a good file is not a small thing. What does that say about the maker? What is obvious throughout the variety of monuments is that each maker had a particular skill. They might have been woodworkers or masons or ironsmiths. Very interesting, in that sense, to simply speculate on their lives. I went no further in my exploration of the individual; that becomes romantic and potentially far from the truth. Many pieces were so old that both the maker and members of his or her community have long since passed on. Because of that I had few if any sources to draw out individual histories.

Milligan: We are using the terms "maker" and "artist" here, but mainly we are talking about ordinary people who would most likely shun the designation of "artist," correct?

Jordan: Absolutely. "Artist" to many people means a famous painter or sculptor; their work is in a museum somewhere or in a book. The term "artist" is incorrect and overused in our society. I feel that these craftsmen were humble and therefore would, as you say, shun the label. But the term artist also implies creativity of a higher level, intention, thought, and deep connection—not just a mechanical response, which is what many of today's "artists" actually do. Yes, they used mechanical devices—but what are paint brushes and burnishing tools?—but it is the intention, the heart and spiritual nature of their work that sets them apart. A person who paints a picture is a painter and an artist. So I feel that to say these craftsmen were makers and artists is not a conflict in describing them for this book.

Milligan: You use an interesting term, "cultural personality." We live in a curious period that both celebrates cultural diversity and, under the banner of being "politically correct," shies away from pointing out cultural specifics. Have you encountered images or scenes that you hesitated to photograph because they were in fact cultural stereotypes?

Jordan: Never. In fact, I was drawn to creations and the possibility of images that clearly showed aspects of the culture through repetition of design or, rather, the concept. That is what this is about. In documenting something, it is not up to me to interpret or judge what I see but only to record it. I have more respect for the individual and the culture than that.

Milligan: You write of the hybridization of Mexican culture. While this is undoubtedly true, the Mexican celebration of *El dia de los*

muertos has become increasingly popular north of the border, all over the United States, in fact. From the changing monuments that people feel are appropriate to honor their deceased loved ones, can you intuit changes in attitudes toward death? If a cultural practice like celebrating the Day of the Dead is spreading along with the U.S. Hispanic population, how do you explain the changing tastes in monuments?

Jordan: The term "hybridization" was borrowed from writer Richard Rodriguez, to give him credit. This celebration actually has its roots deeper in Mexico and rarely came across the border in the early nineteenth century. Much of the rebirth or transference of the Day of the Dead comes from popular travel magazines and newspaper articles, not the current Mexican culture. The Day of the Dead is not about the burial, but about visiting the ancestor every year. This is but another indication of hybridization. Anglos have caught on to this celebration (almost like Mardi Gras). The celebration you speak of is seen moderately in the older pieces, but only through the acts of the current generation.

Milligan: Don't you think that the *Dia de los muertos* tradition of bringing favorite items of the dead to the gravesite might account for some of the stranger items you photographed? I'm thinking of the photograph that includes a plaster/plastic dog.

Jordan: I agree. We see a sharing of practices as in the dog. But the true tradition is a large community-wide celebration in the interior of Mexico. That does not take place here. What I did see on occasion is the gathering of families for "spring cleaning" of the cemetery: mowing, picking up trash, maybe grooming the burial plot. I met one family at a cemetery in Austin that would take their turn, as a family, mowing and cleaning. All of the family was there and they set up tables and shared food. That was a wonderful experience.

Milligan: We did that when I was a child. I guess the practice comes from before the idea of "perpetual care." I noticed an odd practice at the grave of the poet Jane Kenyon, in a small cemetery in New Hampshire. Some of her fans would bring objects that reminded them of something in her poems, and others would carry those same objects away as souvenirs. Did you notice any—perhaps unique—practices that had developed among the numerous cemeteries you studied?

Jordan: There are practices that are shared, and I think this comes from the movement of families from community to community. The use of shells and marbles for decoration, stones left as a sign of visitation, items of personal interest to the deceased, all are widely seen. Artifacts include rosaries, items of particular interest to the deceased, sometimes a beverage of some sort—like beer or soda—and the odd thing for me is the Christmas ornaments and decorations—elaborate at times. I have seen small trees that were decorated. Electric lights, even though there is no electricity, complete a design. Ceramic items generally in the form of some type of figure or animal, frequently animals, and stuffed animals, too—an amazing assortment that always gave me a smile in appreciation.

Milligan: A *camposanto* is land that has been blessed by the Catholic church for the purpose of burying the dead. You have visited

a lot of these, but many small, rural, family cemeteries as well. How does the art differ in these? Do some cemeteries feel more pagan—perhaps indigenous—than Christian?

Jordan: No, not at all. The symbols of the Church were always strongly present, if the money was available. Perhaps by pagan you mean the use of shells or marbles to embellish the design. Shells have a history of meaning that goes back to the Mediterranean countries. I do not know if marbles have any meaning or simply are meant to beautify and create designs.

Milligan: That is one of the things I found most interesting in your photographs: the use of contemporary items within this traditional art form. There are shells, symbols of both death and renewable life, which have almost always adorned graves around the world. But then you have all these plastic figurines of the saints, the Virgin, Christmas angels, the aforementioned dog. That juxtaposition of a crudely nailed-together wooden cross, the name painted on almost artlessly, with these Christian knickknacks, so to speak, from the local religious goods store—does that speak to your notion of cultural hybridization, or do you see this as simply a factor of availability?

Jordan: What you are pointing out is more about availability. Hybridization is about the tombstones changing almost completely, replicating what is seen in Anglo cemeteries. We do not see, with rare exception, the ceramic dog in an Anglo cemetery. That might happen around a child's grave but rarely a teen's or adult's. In the older Mexican cemetery, and even in current ones, we still see the artifacts, the knickknacks, the objects of memory being left, even if the actual tombstone is not made in the tradition of the craftsman. With that example we see a crossing over from one culture to another: hybridization. Even the crudely made cross is still a symbol of the cultural idea of the craftsman to me. It isn't store-bought, off the shelf. Rather, it is made by an individual making do the best they can with what they have. And perhaps at the time of burial that is all they have; the ceramic dog might come later. I have great respect for this.

Milligan: Let me push my earlier question about indigenous and Christian imagery a bit further. I've seen hand-carved angel heads in Mexican cemeteries that looked more like Aztec stone heads than anything else. You have one photo of a cross with what you call "wings"—but they could just as well be crescent moons.

Jordan: I do not know if there is meaning behind that design or simply embellishment, if you will. Your observation of the Aztec points out the hybridization that I am talking about. The Mexican is, basically, a blend of the indigenous Indians and the Spaniards, a hybridization of blood and culture. You spoke of the pagan, which is the Indian, that crosses over and is maintained alongside the Christian. *El dia de los muertos* is pagan in origin. So we see in both practice and creation this blending, this hybridization over centuries. Does it come through visually as crescent moons? I don't know, but that does make me want to look into this work even further.

Milligan: Of course, Our Lady of Guadalupe is always standing on a crescent moon with a snake at her feet. That is definitely Aztec

in origin. But, finally, you photographed a lot of funerary decorations that were in significant states of disrepair, indicating that it might have been years since anyone visited those graves, as if the memories had died away. This seems oddly incongruent to your title, *En recuerdos de.* Tell me what these fallen symbols mean to you.

Jordan: Love and the passing of time, change and all that entails. As I observed the same thing you did, I wondered about the families represented by each grave. Where had they gone? What had they become? Had all died off, or just moved off? Was there no one left to carry on the traditions? And I ask the question: Do modern ways—hybridization—mean better ways, when so many of us feel so lonely and at a loss for connection and family, of belonging? The title is a borrowing of the phrase to indicate my own acknowledgment of these craftsmen. *En recuerdo de,* in memory of . . . them.

Contributors

Martina Will de Chaparro, Ph.D., is an independent scholar based in Denver, Colorado. A former associate professor of history at Texas Woman's University, she is the author of numerous articles and the book *Death and Dying in New Mexico* (University of New Mexico Press, 2007) as well as coeditor of *Death and Dying in Spanish Colonial America* (University of Arizona Press, 2011). In addition to teaching courses on U.S. and Latin American social and political history at Texas Woman's University, Dr. Will has taught courses at Loyola University, Southern Methodist University, and the University of New Mexico. She earned her doctorate from the University of New Mexico, her master's degree in Latin American Studies from the University of California, San Diego, and her bachelor's degree in history and German from the University of Virginia.

E. A. "Tony" Mares is a poet, essayist, translator, and historian. His work has been published internationally—in the United States, Spain, and Mexico. Currently he is at work on a new collection of poems related to the Spanish Civil War.

Bryce Milligan is the author of a dozen books of fiction and poetry and the editor of several literary anthologies, including two of the first major all-Latina anthologies: *Daughters of the Fifth Sun* (New York: Riverhead, 1995) and *iFloricanto Sí!* (New York: Penguin, 1998). For several years he directed the literature program of the Guadalupe Cultural Arts Center in San Antonio, Texas. Milligan is currently the publisher-editor of Wings Press in San Antonio.

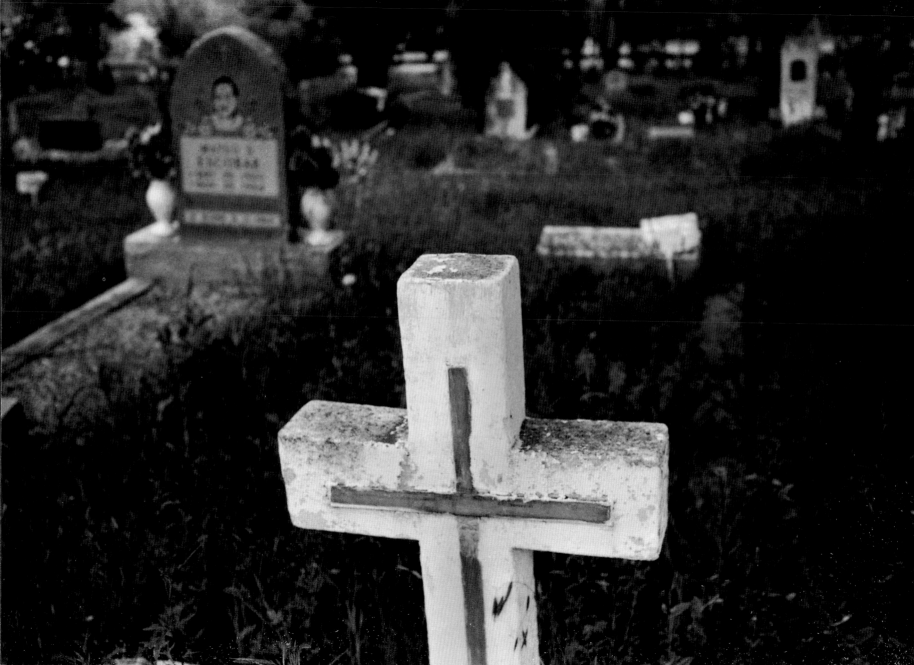

Technical Notes

The traditional look of black-and-white film was requisite for this project. Black-and-white is the look of early photographic drama and documentary projects, from the beginning of photography to the Farm Security Administration photographs and the photo essays of *Look* and *Life* magazines, which I studied endlessly when I was younger whenever the opportunity presented itself. Photography in newspapers, which were once part of the ritual start of the day in my parents' home, used black-and-white photography throughout my youth. For me, therefore, the look of black-and-white is coupled with the notion of age, important images, more intense stories, and history.

Film and older film cameras do not produce the sharpness or crispness in the image to the degree of current digital photography. They have their own "look," which is usually a bit softer. This technical aspect adds to the feeling of age I wanted for this project. We do not see in our daily lives with the clarity that appears in a manipulated digital image, whether in a photograph or high definition television, without considerable visual involvement and heightened concentration. Under normal conditions the mind does not recognize the tiny details or edges and textures and tones captured by digital equipment and enhanced by processing programs. "High-def" is like a mathematical parlor trick.

I chose to use several different camera formats, sacrificing a consistent style for greater creative freedom. Sometimes my mother's old 4x5 Crown Graphic, from the late 1950s, was the right choice due to the look of the lens and the film used when contact printed. At other times the scene dictated the use of an old twin-lens reflex from the 1960s, with its classic square format and less-than-tack-sharp optics when shot wide open. The rectangle of the 35mm format, with its variety of lenses and their capabilities, allowed for a completely different shape of canvas. Sometimes I chose the rather unpredictable Holga, in square format, with its plastic lens and soft focus.

The negative is my canvas; there is no cropping or cutting away of any part of the original image. This is not the case with many

photographs seen in publications today. All images presented in this book, and in all of my work, are full-frame. For the unfamiliar, this means that every part of the image that is seen through the viewfinder at the moment the shot is taken is printed. In shooting with this philosophy and practice I must give each image careful attention, take longer to frame the subject, look closely for details, shapes, shadows, and balance, and not cut away the unwanted at the editing table. For me, this elevates the intentional act of photography to a higher creative level.

Negatives were handprinted then scanned for reproduction. To give the images greater tonal range in the offset printing process, the additional step of creating duotones has been used.

CAMERAS

Canon EOS 1n. Lenses: 20-35mm f2.8L, 35mm f2, 50mm f1.8, 85mm f1.8, 200mm f2.8L EF 12 Ext. Tube (what incredible equipment, gotta love the sound of that motor when it fires!)

Crown Graphic 4x5. Lens: 127mm f4.7 (handed down from my mother)

Yashica 635 Twin-Lens Reflex. Lens: 80mm f3.5 (purchased used for $100 long ago)

Holga 120. Lens: f8 (approximately)

FILM

Ilford HP-5+, 320 ASA. Processed in Kodak D-76

PAPER

Ilford Multigrade Pearl Surface RC

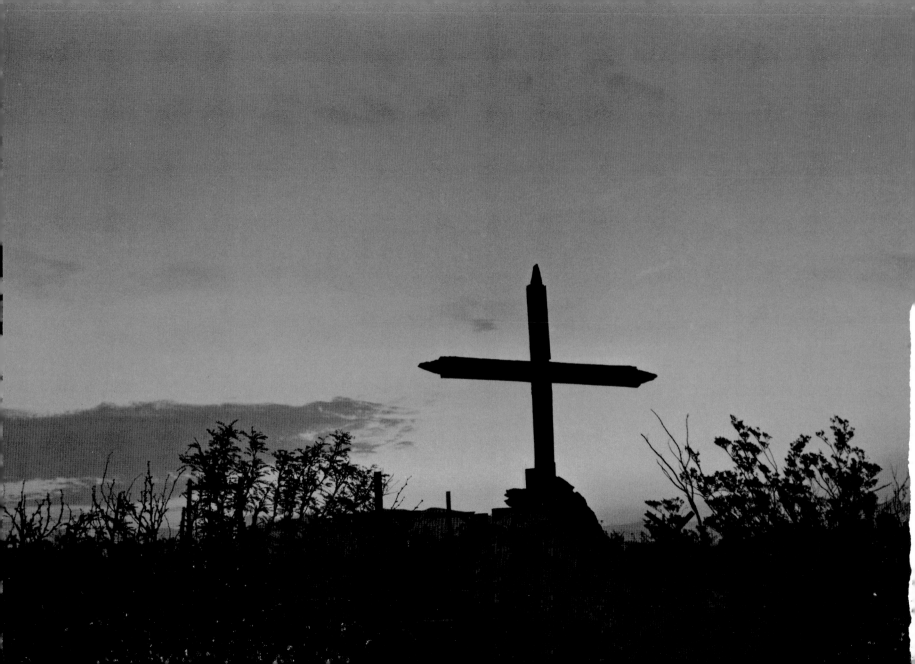